Cool Restaurants London

2nd edition

teNeues

Imprint

Editors: Susanne Olbrich, Martin Nicholas Kunz

Editorial coordination: Katharina Feuer

Photos (location): Damien Russell (43 South Molton), Borris Bags (Automat), courtesy One Aldwych Hotel London (Axis), Tangerine UK (Bam-Bou), Susanne Olbrich (Bam-Bou food, Busaba Eathai food, Fifth Floor food), Herbert Ypma (Busaba Eathai, Hakkasan food, Yauatcha), Tony Robins (Cocoon Restaurant), Martin Nicholas Kunz (Fifteen, Hakkasan, Plateau), David Loftus (Fifteen food), Laurie Fletcher (Mo*vida), Simon Upton (Nobu Berkeley), Sauce Communications (Pétrus), courtesy The River Café Two Easy, published by Ebury Press, 2005 (The River Café food), courtesy Network London & Sketch (Sketch), Ty Simons (The Admiral Codrington), Marc Ltd (Umu). All other photos by Katharina Feuer

Introduction: Guy Dittrich

Layout & Pre-press: Katharina Feuer, Jan Hausberg

Imaging: Jan Hausberg

Translations: SAW Communications, Dr. Sabine A. Werner, Mainz
Ulrike Brandhorst (German / introduction), Elena Nobilini (Italian), Brigitte Villaumié (French), Silvia Gomez de Antonio (Spanish), Nina Hausberg (German, English / recipes)

Special thanks to Nick May for his expert advice.

Produced by fusion publishing GmbH, Stuttgart . Los Angeles www.fusion-publishing.com

Published by teNeues Publishing Group

teNeues Verlag GmbH + Co. KG
Am Selder 37
47906 Kempen, Germany
Tel.: 0049-2152-916-0
Fax: 0049-2152-916-111
Press department:
arehn@teneues.de
Tel.: 0049-2152-916-202

teNeues Publishing UK Ltd.
P.O. Box 402
West Byfleet
KT14 7ZF, Great Britain
Tel.: 0044-1932-403509
Fax: 0044-1932-403514

teNeues
International Sales Division
Speditionstraße 17
40221 Düsseldorf, Germany
Tel.: 0049-211-994597-0
Fax: 0049-211-994597-40
E-mail: books@teneues.de

teNeues France S.A.R.L.
4, rue de Valence
75005 Paris, France
Tel.: 0033-1-55766205
Fax: 0033-1-55766419

teNeues Publishing Company
16 West 22nd Street
New York, NY 10010, USA
Tel.: 001-212-627-9090
Fax: 001-212-627-9511

www.teneues.com

ISBN: 978-3-8327-9131-5

© 2007 teNeues Verlag GmbH + Co. KG, Kempen

Printed in Italy

Bibliographic information published by Die Deutsche Bibliothek.
Die Deutsche Bibliothek lists this publication in the Deutsche Nationalbibliografie;
detailed bibliographic data is available in the Internet at http://dnb.ddb.de.

Average price reflects the average cost for a dinner main course, menu price for a multiple course menu. All prices exclude beverages. Recipes serve four.

Contents

Page

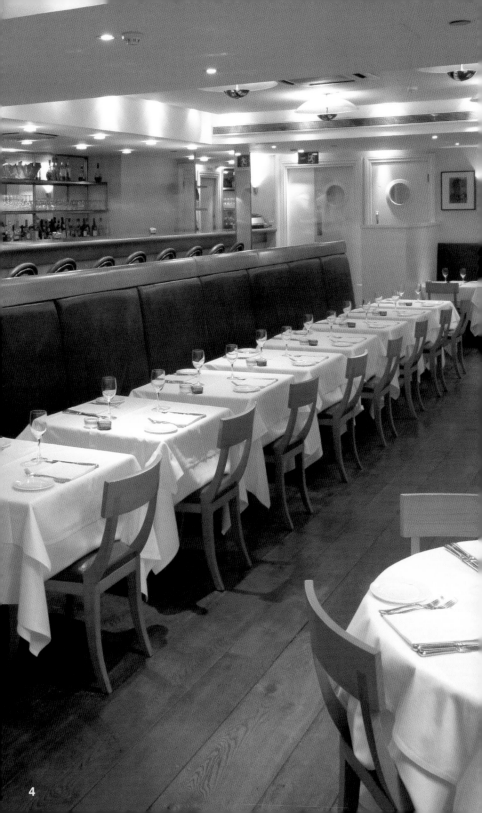

Introduction

This second edition of Cool Restaurants London provides a new close up of a captivating range of restaurants sometimes located in pubs, in stores, in hotels, even in delis. From Kew in the West to Canary Wharf in the city's Eastern Docklands, the geographical spread is matched only by the variety of cuisine. Moroccan and American, Vietnamese and Chinese sit alongside superlative staples from France and Italy.

The celebrity chef phenomenon has made dining out ever more popular, with customers eager to sample the latest offerings from Gordon Ramsey's protégés at the sleek Boxwood and plush purples of Pétrus, or from the people's favorite, Jamie Oliver and his helpers at Fifteen.

The standard of food is a given due to the competitive market place; differentiation is by design. And big names feature here too. Sirs, Richard Rogers and Terence Conran join David Collins and Christian Liaigre in the list of luminaries putting on a great show of constant innovation and longevity in their designs. Be it the refectory like interiors of Rogers' The River Café, well into its second decade, or the new Yauatcha, a great sequel to Liaigre's moody Hakkasan. No lesser achievement is to be found in the more classic feel of the Criterion Grill, with its beautifully restored mosaic ceilings and the eccentric bookcases of 43 South Molton. High design to haute cuisine, London has it all. Bon appétit!

Guy Dittrich

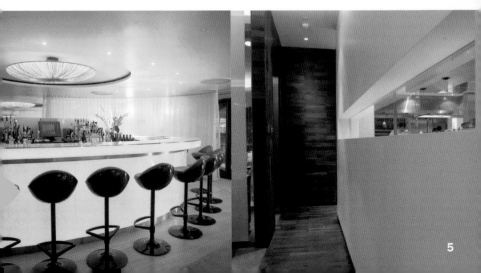

Einleitung

Die zweite Ausgabe von Cool Restaurants London bietet neue Nahaufnahmen von einer faszinierenden Auswahl an Londoner Restaurants, die sich zum Teil in Pubs, Geschäften, Hotels oder sogar in Delis verbergen. Die Vielfalt der kulinarischen Angebote kann sich mit der räumlichen Ausdehnung der Restaurantszene zwischen Kew im Westen und Canary Wharf in den Eastern Docklands von London messen. Hier findet man marokkanische, amerikanische, vietnamesische und chinesische Küche neben französischer und italienischer Kochkunst der Superlative.

Seit dem Entstehen des Phänomens des Celebrity Chef sind Restaurantbesuche so angesagt wie nie: Die Besucher sind ganz heiß auf die neusten Kreationen von Gordon Ramseys Protégés im glamourösen Boxwood und dem vornehm-purpurnen Pétrus – oder von Publikumsliebling Jamie Oliver und seinen Helfern im Fifteen.

Der Wettbewerb unter den Restaurants garantiert einen kulinarischen Qualitäts-standard – der Unterschied liegt im Design. Auch hier sind die großen Namen charakteristisch: Die Sirs Richard Rogers und Terence Conran stehen neben David Collins und Christian Liaigre auf der Liste der Berühmtheiten, die konstant innova-tives und langlebiges Design großartig in Szene setzen. Sei es das Mensa ähnliche Interieur von Rogers' The River Café mit seiner bald zwanzigjährigen Tradition, oder das neue Yauatcha – eine großartige Fortsetzung von Liaigres stimmungsvollem Hakkasan. Nicht weniger vollendet präsentieren sich der eher klassische Criterion Grill, mit seinen wunderschön restaurierten Mosaikdecken und das 43 South Molton mit seinen exzentrischen Bücherregalen. London bietet einfach alles – von High Design bis Haute Cuisine. Bon appétit!

Guy Dittrich

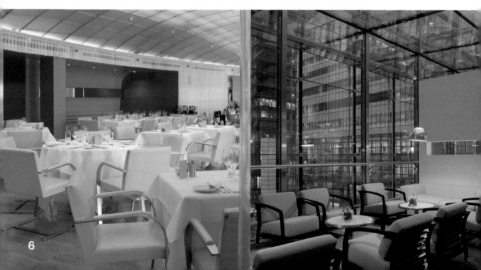

Introduction

La seconde édition des Cool Restaurants London est un nouveau coup de projecteur sur l'extraordinaire diversité des restaurants londoniens qui se cachent parfois dans les pubs, les magasins, les hôtels et même dans les épiceries fines. La richesse de l'offre culinaire n'a d'égal que l'expansion géographique de la scène gastronomique entre Kew à l'ouest et Canary Wharf, les docklands à l'est de Londres. On y rencontre des cuisines marocaine, américaine, vietnamienne et chinoise côtoyant le meilleur de l'art culinaire français et italien.

Depuis l'apparition du phénomène du Celebrity Chef, aller au restaurant est plus que jamais à l'ordre du jour : les convives sont avides de connaître les dernières créations des protégés de Gordon Ramsey au glamoureux Boxwood, du Pétrus au distingué décor pourpre ou encore de Jamie Oliver, le préféré du public avec son équipe du Fifteen.

La concurrence entre les restaurants garantit un standard de qualité culinaire – la différence réside dans le design. Là encore les grands noms sont emblématiques : Les Sirs Richard Rogers et Terence Conran figurent aux côtés de David Collins et Christian Liaigre sur la liste des célébrités qui savent merveilleusement mettre en scène un design toujours innovateur et durable. Ainsi l'intérieur ressemblant à un réfectoire du The River Café de Rogers, un établissement traditionnel depuis presque vingt ans, ou le nouveau Yauatcha – une admirable continuation de l'Hakkasan plein d'atmosphère de Liaigre. Tout aussi accomplis, le Criterion Grill, dans un style plutôt classique avec ses plafonds de mosaïques magnifiquement restaurés et le 43 South Molton avec ses excentriques étagères à livres. Londres sait tout offrir – du High Design à la Haute Cuisine. Bon appétit !

Guy Dittrich

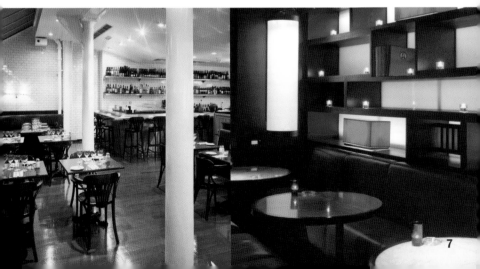

Introducción

La segunda edición de Cool Restaurants London le ofrece nuevos primeros planos de una fascinante selección de restaurantes londinenses, algunos de ellos escondidos en pubs, locales de comercios, hoteles e incluso en tiendas de delicatessen. La variedad de la oferta gastronómica puede medirse con el despliegue espacial de los restaurantes; desde Kew, al oeste, hasta Canary Wharf, en los Docklands del este de Londres. En esta extensión las cocinas marroquíes, americanas, vietnamitas y chinas conviven con las excepcionales gastronomías francesa e italiana.

Desde el surgimiento del fenómeno de los Celebrity Chef las comidas en los restaurantes están más de moda que nunca: los comensales desean degustar las últimas creaciones de los protegidos de Gordon Ramsey en el glamouroso Boxwood y en el elegante y purpúreo Pétrus, o las delicias del preferido del público, Jamie Oliver, y sus ayudantes en Fifteen.

La competitividad entre los restaurantes garantiza una excelente calidad culinaria estándar, la diferencia estriba en el diseño. Aquí destacan también las grandes personalidades: los Sirs Richard Rogers y Terence Conran aparecen, junto con David Collins y Christian Liaigre, en la lista de las celebridades que incorporan constantemente y de forma magistral un diseño innovador y duradero en el ambiente gastronómico. Ya sea el interior similar a un refectorio de Rogers para el The River Café, que dentro de poco cumplirá una tradición de veinte años, como el nuevo Yauatcha, una grandiosa continuación del animado Hakkasan de Liaigre. No menos perfecto es el clásico Criterion Grill, con sus bellos techos restaurados de mosaicos, y el 43 South Molton y sus extravagantes librerías. Londres ofrece sencillamente todo —desde High Design hasta Haute Cuisine. ¡Qué aproveche!

Guy Dittrich

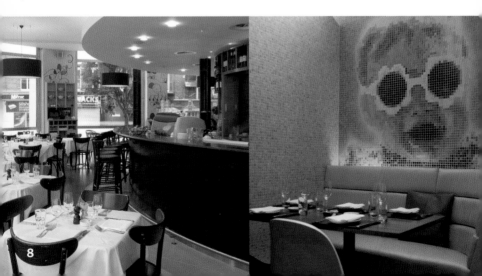

Introduzione

Alla sua seconda edizione, Cool Restaurants London propone nuovi primi piani di un'affascinante selezione di ristoranti londinesi, nascosti, talvolta, in pubs, botteghe, alberghi o persino in negozi di specialità gastronomiche. L'offerta culinaria è tanto ricca quanto la scelta di ristoranti tra Kew, ad ovest di Londra, e Canary Wharf, nelle Eastern Docklands della città. Le cucine marocchina, americana, vietnamita e cinese convivono, qui, con le delizie dell'arte culinaria francese e italiana.

Andare al ristorante non è mai stato così di moda come dalla nascita del fenomeno del Celebrity Chef. I frequentatori vanno pazzi per le nuovissime creazioni dei protetti di Gordon Ramsey all'affascinante Boxwood, dell'esclusivo e purpureo Pétrus o del beniamino del pubblico Jamie Oliver e dei suoi assistenti al Fifteen.

La concorrenza tra i ristoranti garantisce standard culinari elevati: la differenza sta nel design, anch'esso contraddistinto da grandi nomi. Oltre ai Sirs Richard Rogers e Terence Conran, sulla lista delle celebrità appaiono anche David Collins e Christian Liaigre, tutti proponitori di un design costantemente innovativo e duraturo. Sia che si tratti degli interni tipo mensa del The River Café di Rogers, con la sua tradizione quasi ventennale, o del nuovo Yauatcha, grandiosamente ideato sulla scia degli interni suggestivi dell'Hakkasan di Liaigre. Altrettanto perfetti sono il Criterion Grill, dallo stile più classico con i suoi soffitti a mosaico splendidamente restaurati, e il 43 South Molton, con le sue eccentriche librerie. Londra offre proprio di tutto – da high design a haute cuisine. Bon appétit!

Guy Dittrich

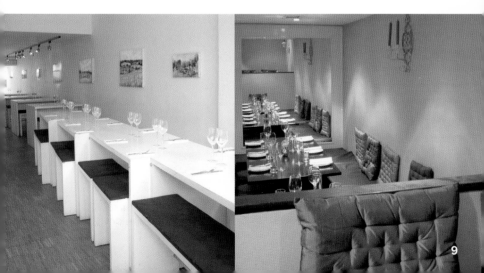

43 South Molton

Design: Russell Sage | Chef: Martin St Marie
Owner: Jasper Tay, Ameet Mehta

43 South Molton Street | London, W1K 5RS | Mayfair
Phone: + 44 20 7647 4343
www.43southmolton.com
Tube: Bond Street, Oxford Circus
Opening hours: Mon–Sat 11 am to 3 am, Sun 11 am to 11 pm
Average price: £20
Cuisine: Modern European
Special features: The ballroom is available for private hire

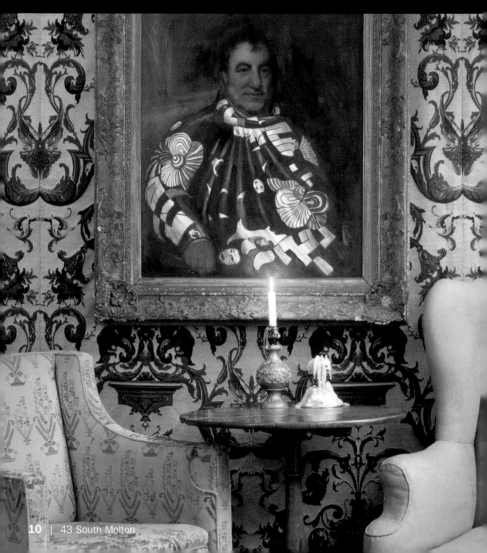

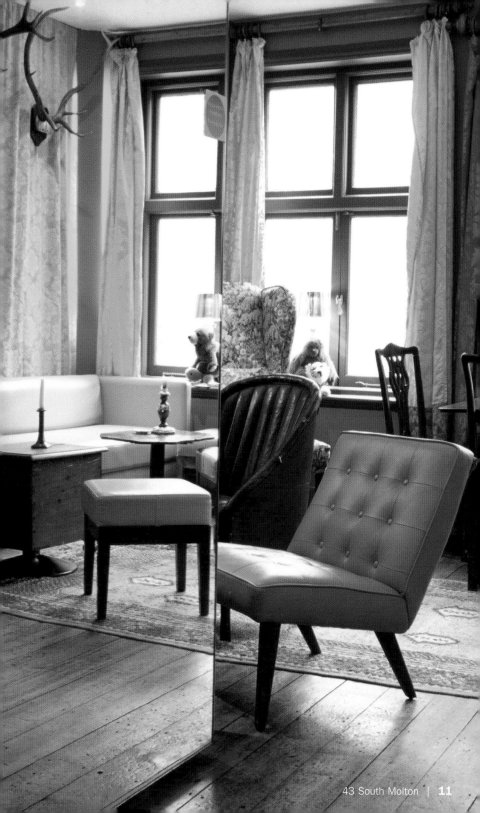

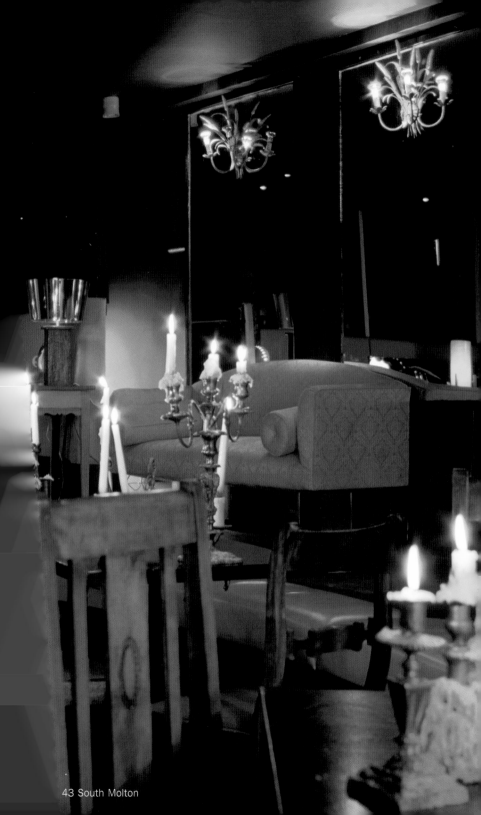

43 South Molton

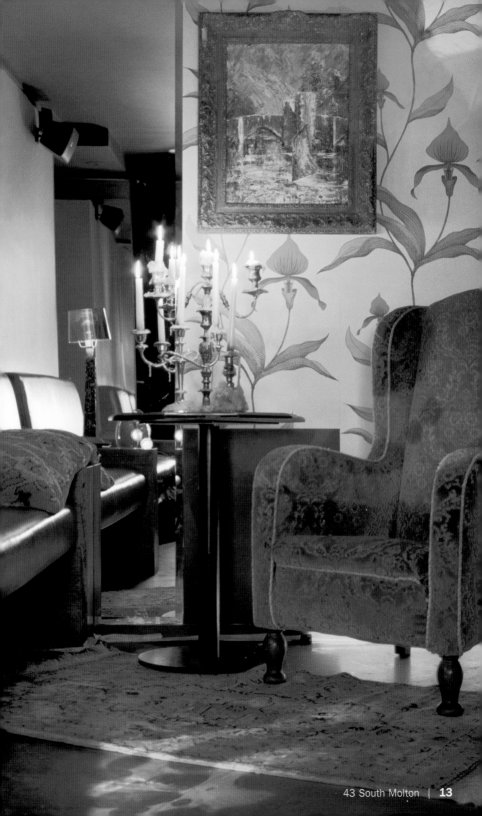

Automat

Design: Carlos Almada | Chef: Peter Tempelhoff
Owners: 17 Berkeley Street Ltd / Carlos Almada

33 Dover Street | London, W1S 4NF | Mayfair
Phone: +44 20 7499 3033
www.automat-london.com | info@automat-london.com
Tube: Green Park
Opening hours: Lunch Mon–Fri noon to 3 pm, dinner Mon–Sat 6 pm to 11 pm,
brunch Sat–Sun 11 am to 4 pm
Average price: £14
Cuisine: North American

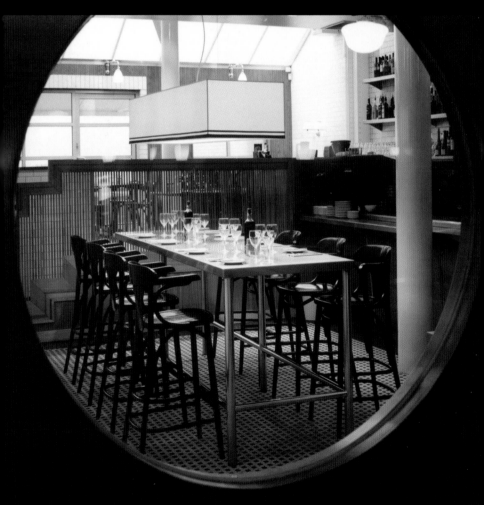

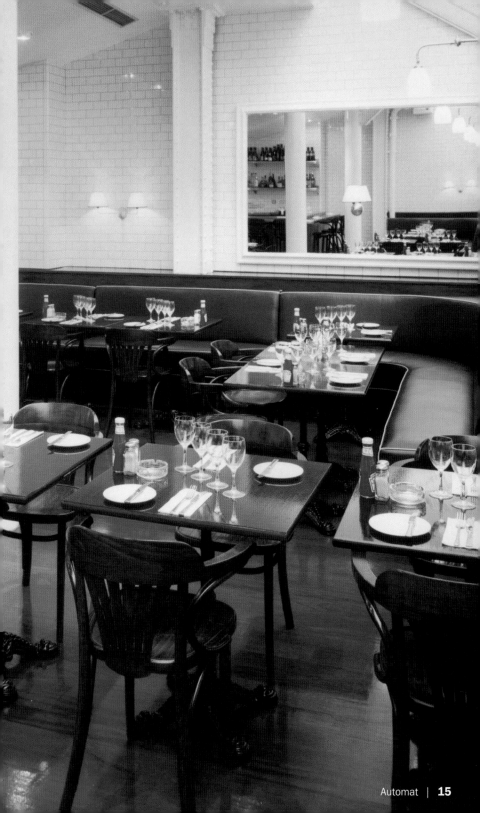

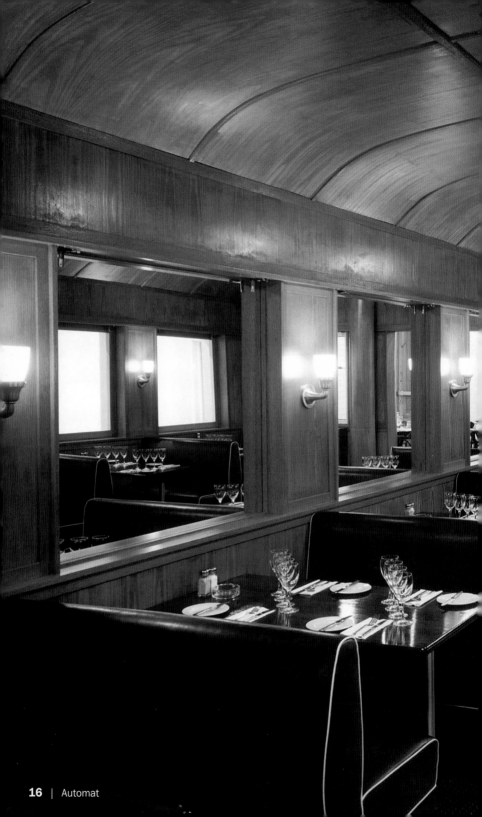

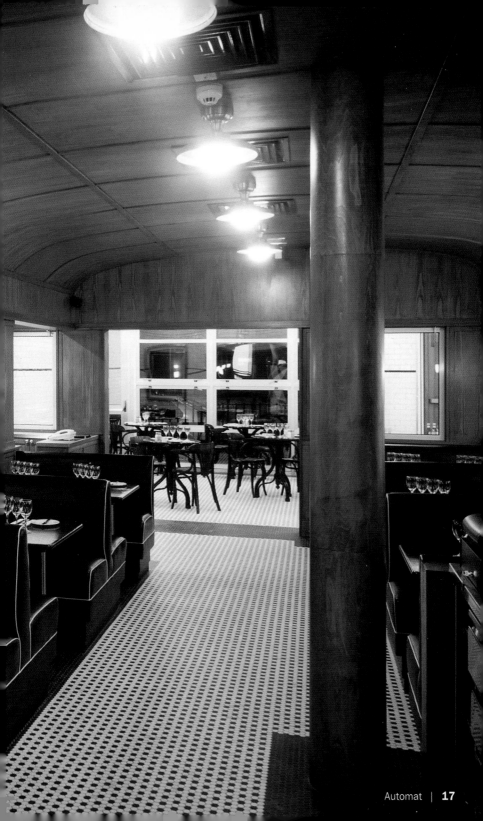

Axis

Design: Mary Fox Linton & Gordon Campbell Gray
Chef: Mark Gregory | Owner: One Aldwych Hotel London

1 Aldwych | London, WC2B 4RH | Covent Garden
Phone: +44 20 7300 0300
www.onealdwych.com | axis@onealdwych.com
Tube: Covent Garden
Opening hours: Lunch Mon–Fri noon to 2:45 pm, dinner Mon–Fri 5:45 pm to
10:45 pm, dinner Sat 5:45 pm to 11:30 pm
Average price: £18
Cuisine: Modern European

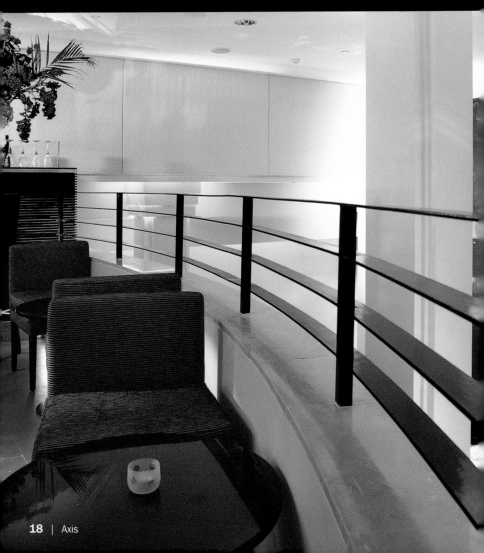

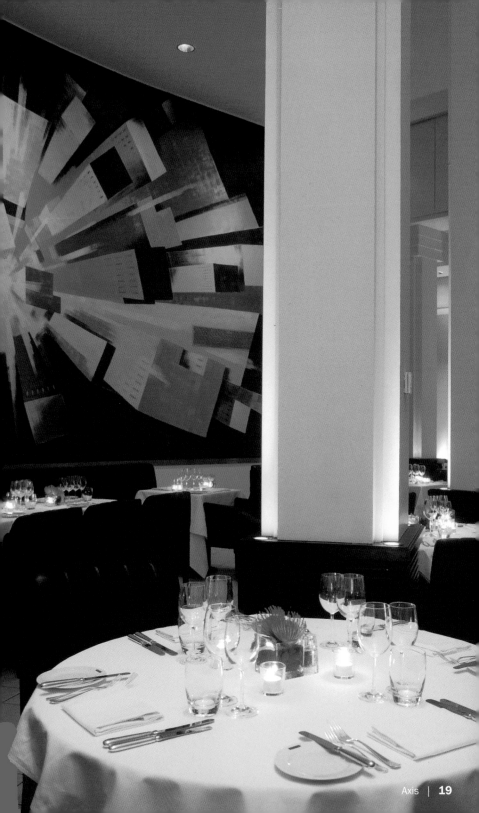

Bam-Bou

Chef: Gary Lee | Owner: Caprice Holdings Ltd

1 Percy Street | London, W1T 1DB | Fitzrovia
Phone: +44 20 7323 9130
www.bam-bou.co.uk | reservations@bam-bou.co.uk
Tube: Goodge Street, Tottenham Court Road
Opening hours: Mon–Fri noon to 3 pm, 6 pm to 11 pm, Sat 6 pm to 11 pm,
the Red Bar: Mon–Sat 6 pm to 1 am
Average price: £12
Cuisine: French-Vietnamese
Special features: Lounge Bar and private rooms

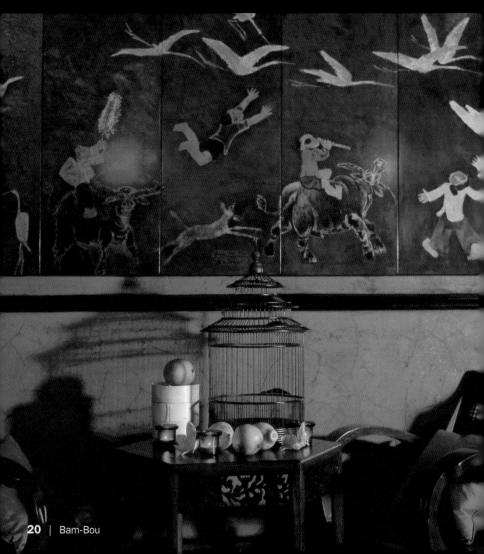

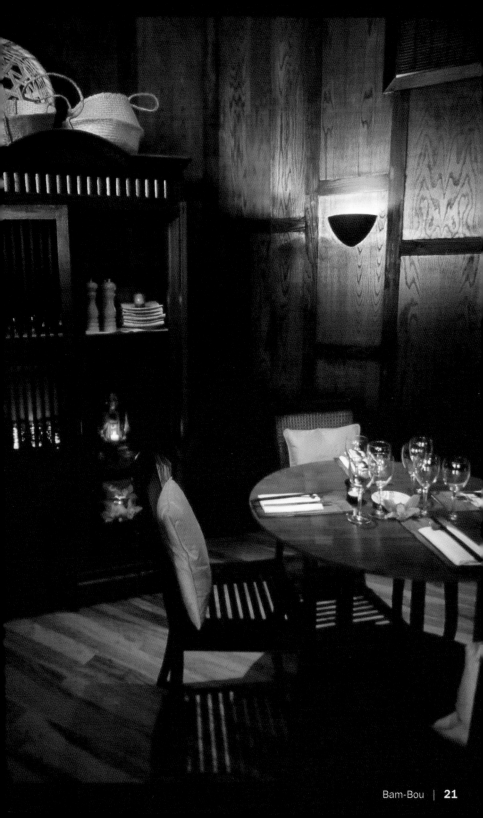

Roasted Duck

Geröstete Ente

Canard rôti

Pato asado

Anatra arrosto

2 ducks with hearts and livers, 4 pounds each
18 oz goose fat
2 stems lemon grass, chopped roughly
2 tbsp ginger, chopped roughly
4 cloves of garlic, chopped roughly
2 star anise
Salt, pepper
2 tsp Szechuan-pepper
2 tbsp soy sauce
2 tbsp rice vinegar
1 tbsp sesame oil
2 spring onions, cut in rings
4 oz Asian lettuce and sprouts
Cilantro leaves for decoration

Remove the duck legs, clean the bottom bone and remove the upper bone from the leg. Place the duck legs with the goose fat and the season-ings in a pot and cook in a 300 °F oven for about 1 hour. Let cool in fat. Cut out the duck breasts and rub with pepper and soy sauce. Set aside. Remove the left skin from the carcasses and blanch in little water for 3 minutes. Drain and set aside. Remove the duck legs from the fat and roast in a 390 °F oven for 30 minutes. Season the duck breasts and sear from both sides for 3 minutes. Place with the duck legs in the oven for 5 minutes. In the meantime, fry the hearts and livers and cut in thin slices. Combine with the Asian lettuce, spring onions, vinegar and oil and divide onto four plates. Deep-fry the cooked duck skin in oil until crunchy and place on top of the salad. Cut the duck breast in thin slices and place next to the salad, put one duck leg on top of each salad.

2 Enten mit Herz und Leber à 2 kg
500 g Gänseschmalz
2 Stangen Zitronengras, grob gehackt
2 EL Ingwer, grob gehackt
4 Knoblauchzehen, grob gehackt
2 Sternanis
Salz, Pfeffer
2 TL Szechuan-Pfeffer, grob gemahlen
2 EL Sojasauce
2 EL Reisessig
1 EL Sesamöl
2 Frühlingszwiebeln, in Ringen
100 g asiatische Salatblätter und Sprossen
Korianderblätter zur Dekoration

Entenschlegel abtrennen, den unteren Knochen blank putzen und den oberen Knochen des Beines herauslösen. Die Entenschlegel zusam-men mit dem Gänseschmalz und den Gewürzen in einen Topf geben und im Ofen bei 150 °C ca. 1 Stunde garen. Im Fett abkühlen lassen. Die Entenbrüste herauslösen und mit Pfeffer und Sojasauce einreiben. Beiseite stellen. Die restliche Haut von den Karkassen lösen und in etwas Wasser 3 Minuten blanchieren. Abgießen und kaltstellen. Die Entenschlegel aus dem Fett nehmen und bei 200 °C ca. 30 Minuten im Ofen rösten. Die Entenbrüste würzen und von beiden Seiten 3 Minuten braten. Für 5 Minuten zu den Schlegeln in den Ofen geben. In der Zwischenzeit die Herzen und Lebern anbraten und in dünne Scheiben schneiden. Mit dem asiatischen Salat, den Frühlingszwiebeln, Essig und Öl mischen und auf vier Tellern verteilen. Die gekochte Entenhaut in etwas Öl knusprig frittieren und auf den Salat geben. Die Entenbrüste in dünne Scheiben schneiden und neben den Salat setzen, jeweils einen Schlegel auf den Salat legen.

2 canards avec le cœur et le foie de 2 kg chacun
500 g de saindoux d'oie
2 branches de citronnelle hachées grossièrement
2 c. à soupe de gingembre haché grossièrement
4 gousses d'ail hachées grossièrement
2 étoiles de badiane
Sel, poivre
2 c. à café de poivre du Sechuan moulu grossièrement
2 c. à soupe de sauce de soja
2 c. à soupe de vinaigre de riz
1 c. à soupe d'huile de sésame
2 oignons printaniers en rondelles
100 g de feuilles de salade asiatique et de pousses
Feuilles de coriandre pour la décoration

Lever les cuisses de canard, nettoyer à blanc l'os du bas et dégager l'os du haut de la cuisse. Mettre les cuisses de canard avec le saindoux et les épices dans une marmite et faire cuire au four à 150 °C pendant env. 1 heure. Laisser refroidir dans la graisse. Détailler les magrets et les badigeonner de poivre et de sauce de soja. Les réserver. Enlever le reste de la peau des carcasses et la blanchir 3 minutes dans un peu d'eau. Égoutter et mettre au frais. Retirer les cuisses de la graisse et les faire rôtir au four à 200 °C pendant env. 30 minutes. Assaisonner les magrets et les faire cuire 3 minutes de chaque côté. Les joindre aux cuisses dans le four pendant 5 minutes. Pendant ce temps, faire revenir les cœurs et les foies, les couper en fines tranches. Les mélanger à la salade asiatique avec les oignons printaniers, le vinaigre et l'huile et répartir sur quatre assiettes. Faire frire la peau de canard cuite dans un peu d'huile pour qu'elle devienne croustillante et l'ajouter à la salade. Couper les magrets en fines tranches, les placer à côté de la salade, déposer une cuisse sur la salade.

2 patos con el corazón y el hígado, de 2 kg cada uno
500 g de manteca de ganso
2 ramas de limoncillo, ligeramente picadas
2 cucharadas de jengibre, ligeramente picado
4 dientes de ajo, ligeramente picados
2 aníses estrella
Sal, pimienta
2 cucharaditas de pimienta de Sichuan, ligeramente molida
2 cucharadas de salsa de soja
2 cucharadas de vinagre de arroz
1 cucharada de aceite de sésamo
2 cebolletas, en aros
100 g de hojas de lechuga y brotes asiáticos
Hojas de cilantro para decorar

Separe los muslos de pato, limpie completamente el hueso inferior y extraiga el hueso superior de la pata. Ponga los muslos junto con la manteca de ganso y las especias en una cazuela y áselos en el horno durante aprox. 1 hora a 150 °C. Deje enfriar la carne en la grasa. Separe las pechugas de pato y frótelas con la pimienta y la salsa de soja. Quite el resto de la piel del cuerpo y escáldela durante 3 minutos. Vierta el agua y deje enfriar la piel. Saque los muslos de la grasa y áselos en el horno durante aprox. 30 minutos a 200 °C. Condimente las pechugas y fríalas durante 3 minutos por cada lado. Introdúzcalas después en el horno y áselas junto con los muslos durante 5 minutos. En ese tiempo fría los corazones y los hígados y córtelos en finas rodajas. Mezcle esta carne con la lechuga asiática, las cebolletas, el vinagre y el aceite y reparta los ingredientes en cuatro platos. Fría la piel en un poco de aceite hasta que esté crujiente y añádala a la ensalada. Corte las pechugas en finas rodajas y póngalas al lado de la ensalada. Coloque una pechuga sobre la ensalada de cada plato.

2 anatre con cuore e fegato da 2 kg l'una
500 g di strutto d'oca
2 gambi di cimbopogone tritati grossolanamente
2 cucchiai di zenzero tritato grossolanamente
4 spicchi d'aglio tritati grossolanamente
2 anici stellati
Sale, pepe
2 cucchiaini di pepe Sichuan macinato grosso
2 cucchiai di salsa di soia
2 cucchiai di aceto di riso
1 cucchiaio di olio di sesamo
2 cipollotti a rondelle
100 g di foglie d'insalata e germogli asiatici
Foglie di coriandolo per decorare

Staccate le cosce delle anatre, pulite bene l'osso inferiore e disossate la parte superiore della coscia. Mettete le cosce in un tegame insieme allo strutto d'oca e agli aromi e fatele cuocere in forno caldo a 150 °C per ca. 1 ora. Lasciate raffreddare nel grasso. Staccate i petti di anatra e sfregateli con pepe e salsa di soia. Metteteli da parte. Staccate la pelle restante dalle carcasse e sbollentatela in un po d'acqua per 3 minuti. Scolatela e mettetela a raffreddare. Togliete le cosce di anatra dal grasso e arrostitele nel forno caldo a 200 °C per ca. 30 minuti. Condite i petti di anatra e cuoceteli in padella da entrambi i lati per 3 minuti. Passateli in forno insieme alle cosce per 5 minuti. Nel frattempo fate rosolare i cuori e i fegati e tagliateli a fette sottili. Mescolateli all'insalata asiatica, ai cipollotti, all'aceto e all'olio e distribouiteli su quattro piatti. In un po' di olio friggete la pelle di anatra sbollentata fino a renderla croccante e sistematela sull'insalata. Tagliate i petti di anatra a fette sottili e disponeteli vicino all'insalata, sistemate una coscia su ogni insalata.

Design: Barbara Barry | Head Chef: Stuart Gillies
Owner: Gordon Ramsay

Wilton Place | London, SW1X 7RL | Knightsbridge
Phone: +44 20 7235 1010
www.gordonramsay.com | boxwoodcafe@gordonramsay.com
Tube: Hyde Park Corner
Opening hours: Lunch Mon–Fri noon to 3 pm, Sat–Sun noon to 4 pm,
dinner Mon–Sun 6 pm to 11 pm
Average price: £19
Cuisine: Modern English with continental influence

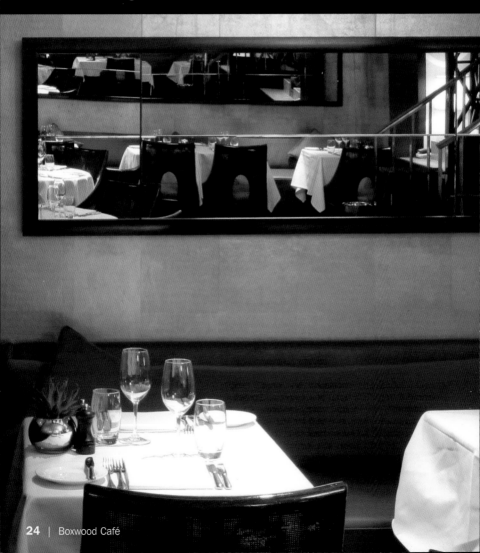

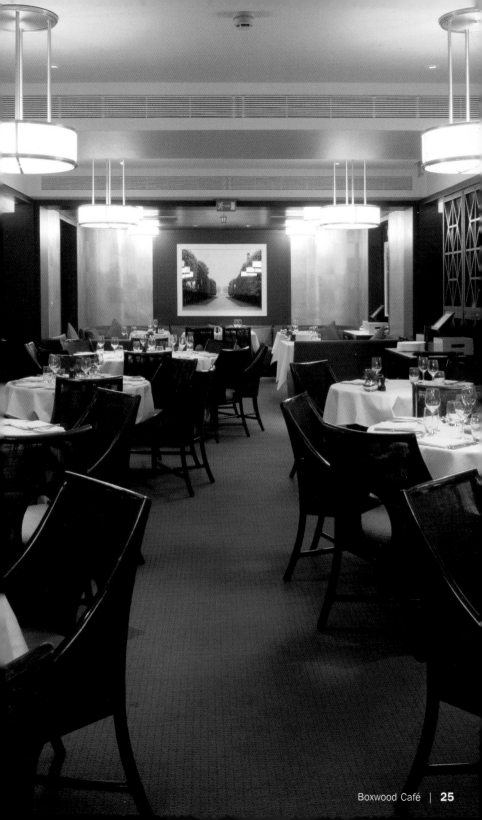

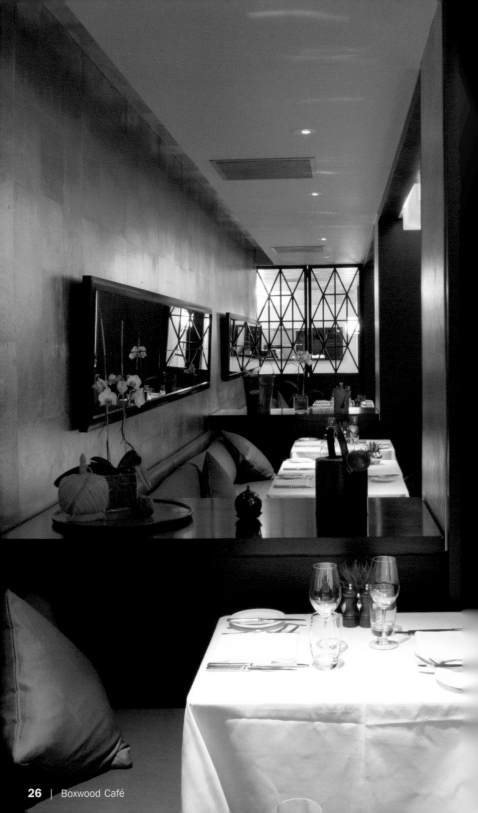

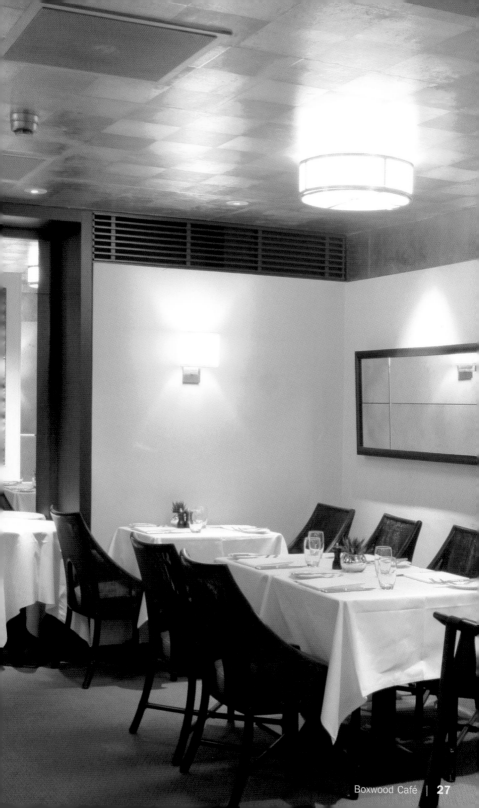

Lamb Stew

Lammragout

Ragout d'agneau

Ragú de cordero

Ragù di agnello

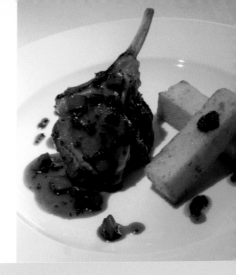

8 lamb chops in one piece
4 tbsp vegetable oil
1 carrot, diced
1 onion, diced
1 small celeriac, diced
2 cloves of garlic
1 twig rosemary
1 twig thyme
2 tbsp tomato paste
1 l broth

Season the lamb chops and sear in hot oil, remove from the pan. Sear the vegetables in the same oil. Add herbs and tomato paste and fill up with broth. Put the meat back into the pan and braise with a lid until tender.

500 ml milk
200 ml cream
1 clove of garlic, chopped
7 oz corn semolina
Salt, pepper
2 tbsp butter
3 tbsp parmesan, grated

Bring milk, cream and garlic to a boil, stir in the corn semolina and cook for 10 minutes while stirring constantly. Add butter and parmesan and season with salt and pepper. Pour onto a greased baking sheet and set aside until firm. Cut in slices and fry in butter. Cut the lamb chops in separate pieces and keep warm. Strain the sauce, season and thicken if necessary. Place two lamb chops and two slices of polenta on each plate and drizzle with sauce.

8 Lammkoteletts am Stück
4 EL Pflanzenöl
1 Karotte, gewürfelt
1 Zwiebel, gewürfelt
1 kleiner Sellerie, gewürfelt
2 Knoblauchzehen
1 Zweig Rosmarin
1 Zweig Thymian
2 EL Tomatenmark
1 l Brühe

Die Lammkoteletts würzen und scharf anbraten, aus der Pfanne nehmen. Das Gemüse in dem gleichen Fett anbraten. Die Kräuter und das Tomatenmark zugeben und mit Brühe ablöschen. Das Fleisch zurück in die Pfanne geben und zudeckt weich schmoren lassen.

500 ml Milch
200 ml Sahne
1 Knoblauchzehe, gehackt
200 g Maisgrieß
Salz, Pfeffer
2 EL Butter
3 EL Parmesan, gerieben

Milch, Sahne und Knoblauch aufkochen, den Maisgrieß einrühren und unter kräftigem Rühren ca. 10 Minuten garen. Butter und Parmesan unterrühren und mit Salz und Pfeffer würzen. Auf ein gefettetes Backblech geben und fest werden lassen. In Scheiben schneiden und in Butter anbraten. Die Lammkoteletts zerteilen und warm stellen. Die Sauce passieren, abschmecken und evtl. andicken. Jeweils zwei Koteletts und zwei Scheiben Polenta auf einem Teller anrichten und mit Sauce beträufeln.

8 côtelettes d'agneau en une pièce
4 c. à soupe d'huile végétale
1 carotte en dés
1 oignon en dés
1 petit céleri en dés
2 gousses d'ail
1 branche de romarin
1 branche de thym
2 c. à soupe de concentré de tomates
1 l de bouillon

Assaisonner les côtelettes et les faire colorer à feu vif, les retirer de la sauteuse. Faire revenir les légumes dans la même huile. Y ajouter les herbes et le concentré de tomates et déglacer avec le bouillon. Remettre la viande dans la sauteuse et laisser mijoter à couvert jusqu'à ce qu'elle soit tendre.

500 ml de lait
200 ml de crème
1 gousse d'ail hachée
200 g de semoule de maïs
Sel, poivre
2 c. à soupe de beurre
3 c. à soupe de parmesan râpé

Amener le lait, la crème et l'ail à ébullition, verser la semoule et faire cuire env. 10 minutes en remuant vigoureusement. Ajouter le beurre et le parmesan, assaisonner de sel et de poivre. Etaler la polenta sur une tôle graissée et la laisser prendre. La couper en tranches et les faire revenir dans du beurre. Découper les côtelettes d'agneau et les conserver au chaud. Passer la sauce au chinois, rectifier l'assaisonner et la faire épaissir éventuellement. Disposer deux côtelettes et deux tranches de polenta sur une assiette et arroser de sauce.

8 chuletas de cordero en una pieza
4 cucharadas de aceite vegetal
1 zanahoria, en dados
1 cebolla, en dados
1 apio pequeño, en dados
2 dientes de ajo
1 rama de romero
1 rama de tomillo
2 cucharadas de concentrado de tomate
1 l de caldo

Condimente las chuletas y fríalas a fuego fuerte. Sáquelas de la sartén. Rehogue las verduras en esa misma grasa. Añada las hierbas y el concentrado de tomate y vierta por encima el caldo para parar la cocción. Ponga la carne nuevamente en la sartén, tápela y deje que se estofe a fuego lento.

500 ml de leche
200 ml de nata
1 diente de ajo, picado
200 g de sémola de maíz
Sal, pimienta
2 cucharadas de mantequilla
3 cucharadas de queso parmesano, rallado

Hierva la leche con la nata y el ajo, añada la sémola de maíz y deje que cueza durante aprox. 10 minutos sin dejar de remover. Añada la mantequilla y el queso parmesano y remueva. Salpimiente. Extienda la mezcla sobre una bandeja de horno engrasada y deje que se endurezca. Córtela en rodajas y fríala en mantequilla. Separe las chuletas y manténgalas en un lugar caliente. Pase la salsa, sazónela y, si es necesario, espésela. Coloque en cada plato dos chuletas con dos rodajas de polenta y vierta por encima la salsa.

8 braciole di agnello in un pezzo unico
4 cucchiai di olio vegetale
1 carota tagliata a dadini
1 cipolla tagliata a dadini
1 sedano piccolo tagliato a dadini
2 spicchi d'aglio
1 rametto di rosmarino
1 rametto di timo
2 cucchiai di concentrato di pomodoro
1 l di brodo

Condite le braciole di agnello e fatele rosolare bene, toglietele quindi dalla padella. Nello stesso grasso fate rosolare anche la verdura. Aggiungete le erbe aromatiche e il concentrato di pomodoro e bagnate con il brodo. Rimettete la carne nella padella e fatela stufare a tegame coperto finché sarà tenera.

500 ml di latte
200 ml di panna
1 spicchio d'aglio tritato
200 g di semolino di mais
Sale, pepe
2 cucchiai di burro
3 cucchiai di parmigiano grattugiato

Portate ad ebollizione il latte e la panna con l'aglio, stemperatevi il semolino di mais e fate cuocere il tutto per ca. 10 minuti mescolando energicamente. Incorporatevi il burro e il parmigiano, salate e pepate. Versate su una piastra da forno unta e lasciate rassodare. Tagliate a fette e rosolatele nel burro. Dividete le braciole di agnello e mettetele in caldo. Colate la salsa, correggetela di sapore e, se necessario, addensatela. Mettete su ogni piatto rispettivamente due braciole e due fette di polenta e versatevi alcune gocce di salsa.

22 Store Street | London WC1E 7DF | Bloomsbury
Phone: +44 20 7299 7900
Tube: Goodge Street
Opening hours: Mon–Thu noon to 11 pm, Fri–Sat noon to 11:30 pm,
Sun noon to 10 pm
Average price: £8.50
Cuisine: Thai
Special features: Communal dining

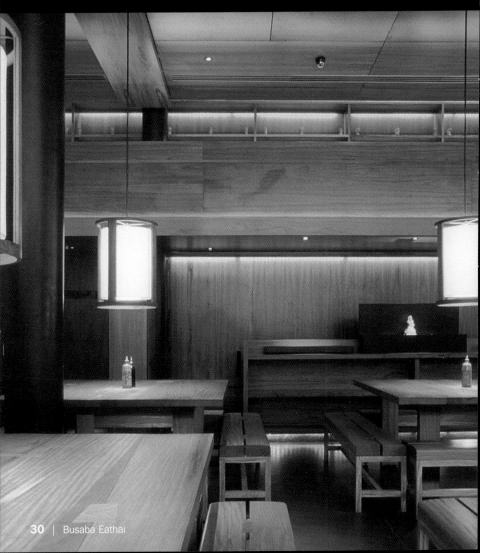

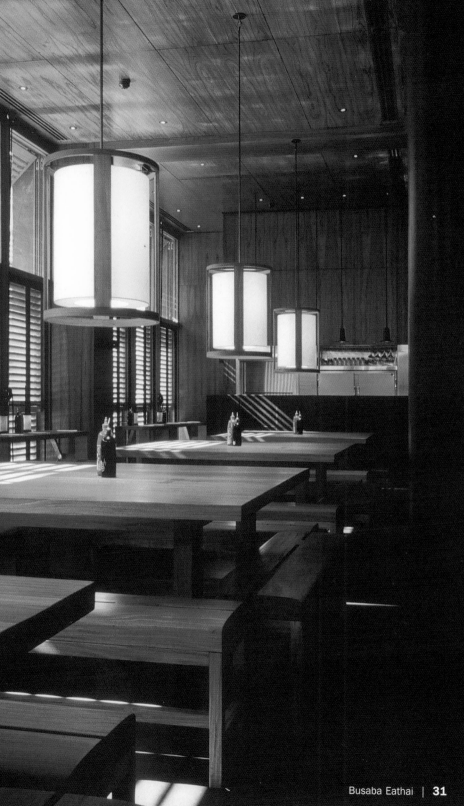

Duck-Mussaman-Curry

Enten-Mussaman-Curry

Canard au curry mussaman

Patos al curry mussaman

Anatra al curry di Mussaman

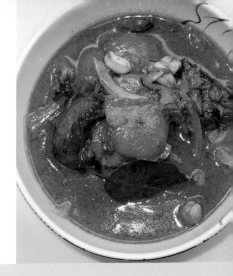

4 duck legs without skin and bone
2 star anise
6 tbsp soy sauce
4 medium size potatoes, peeled and diced into
1 inch cubes
Vegetable oil for deep-frying

3 tbsp Thai-Mussaman-Curry paste
5 Thai-cardamon pods
1 stick cinnamon
4 bay leaves
500 ml coconut milk
350 ml coconut cream
4 tbsp fish sauce
2 tbsp sugar
200 ml pineapple juice
Salt, pepper
2 onions, diced and blanched
4 oz peanuts, roasted

Cut the duck legs into rough chunks and marinade with the star anise and soy sauce for at least 2 hours. Heat the oil in a wok and first fry the potato cubes, then the marinated duck meat for 4 minutes each. Place duck meat and potatoes on kitchen towel and set aside. Remove the oil from the wok and sauté curry paste, cardamon pods, cinnamon stick and bay leaves with the duck meat. Fill up with coconut milk and cream and let simmer for approx. 20 minutes. Season with fish sauce, sugar, pineapple juice, salt and pepper. Add potato cubes, diced onions and peanuts. Serve with rice.

4 Entenschlegel, ohne Haut und Knochen
2 Sternanis
6 EL Sojasauce
4 mittlere Kartoffeln, geschält und in ca. 3 cm
große Würfel geschnitten
Pflanzenöl zum Frittieren

3 EL Thai-Mussaman-Currypaste
5 Thai-Kardamonkapseln
1 Zimtstange
4 Lorbeerblätter
500 ml Kokosnussmilch
350 ml Kokosnusssahne
4 EL Fischsauce
2 EL Zucker
200 ml Ananassaft
Salz, Pfeffer
2 Zwiebeln, gewürfelt und blanchiert
120 g Erdnüsse, geröstet

Die Entenschlegel in grobe Stücke schneiden und mit dem Sternanis und der Sojasauce für mind. 2 Stunden marinieren. Das Öl in einem Wok erhitzen und zuerst die Kartoffeln, dann die marinierten Entenstücke für jeweils 4 Minuten frittieren. Entenfleisch und Kartoffeln abtropfen lassen und beiseite stellen. Das Öl aus dem Wok entfernen und die Currypaste, Kardamonkapseln, Zimtstange und Lorbeerblätter mit dem Entenfleisch anschwitzen. Mit Kokosnussmilch und Kokosnusssahne aufgießen und ca. 20 Minuten köcheln lassen. Mit Fischsauce, Zucker und Ananassaft abschmecken und mit Salz und Pfeffer würzen. Die Kartoffelwürfel, Zwiebel und Erdnüsse unterheben. Mit Reis servieren.

4 cuisses de canard désossées, sans la peau
2 étoiles de badiane
6 c. à soupe de sauce de soja
4 pommes de terre moyennes pelées et coupées
en dés d'env. 3 cm
Huile végétale pour la friture

3 c. à soupe de pâte de curry thaï mussaman
5 capsules de cardamome thaï
1 bâton de cannelle
4 feuilles de laurier
500 ml de lait de noix de coco
350 ml de crème de noix de coco
4 c. à soupe de sauce de poisson
2 c. à soupe de sucre
200 ml de jus d'ananas
Sel, poivre
2 oignons en dés et blanchis
120 g de cacahuètes grillées

Découper les cuisses de canard en gros morceaux et les faire mariner pendant au moins 2 heures avec les étoiles de badiane et la sauce de soja. Faire chauffer l'huile dans un wok et faire frire d'abord les pommes de terre, ensuite les morceaux de canard marinés pendant respectivement 4 minutes. Egoutter la viande et les pommes de terre et réserver. Retirer l'huile du wok et réchauffer la pâte de curry, les capsules de cardamone, le bâton de cannelle et les feuilles de laurier avec la viande de canard. Arroser de lait et de crème de noix de coco et laisser frémir pendant env. 20 minutes. Achever l'assaisonnement avec la sauce de poisson, le sucre et le jus d'ananas et rectifier avec sel et poivre. Ajouter les pommes de terre en dés, l'oignon et les cacahuètes. Servir avec du riz.

4 muslos de pato, sin piel y deshuesados
2 aníses estrella
6 cucharadas de salsa de soja
4 patatas medianas, peladas y en dados de
aprox. 3 cm
Aceite vegetal para freír

3 cucharadas de pasta de curry thai mussaman
5 cápsulas de cardamomo thai
1 rama de canela
4 hojas de laurel
500 ml de leche de coco
350 ml de nata de coco
4 cucharadas de salsa de pescado
2 cucharadas de azúcar
200 ml de zumo de piña
Sal, pimienta
2 cebollas, en dados y escaldadas
120 g de cacahuetes, tostados

Corte los muslos en trozos grandes y marínelos junto con el anís y la salsa de soja durante al menos 2 horas. Caliente el aceite en un wok y fría primeramente las patatas y después el pato marinado durante 4 minutos respectivamente. Escurra la carne y las patatas y reserve. Deseche el aceite y saltee en el wok la pasta de curry, las cápsulas de cardamomo, la rama de canela y las hojas de laurel junto con a carne de pato. Vierta dentro la leche y la nata de coco y deje que cueza durante aprox. 20 minutos. Sazone con la salsa de pescado, el azúcar y el zumo de piña y salpimiente. Añada los dados de patata, la cebolla y los cacahuetes y remueva. Sirva con arroz.

4 cosce di anatra senza pelle e ossi
2 anici stellati
6 cucchiai di salsa di soia
4 patate medie pelate e tagliate a dadini di ca. 3 cm
Olio vegetale per friggere

3 cucchiai di pasta di curry tailandese di Mussaman
5 capsule di cardamomo del Siam
1 bastoncino di cannella
4 foglie di alloro
500 ml di latte di noce di cocco
350 ml di panna di cocco
4 cucchiai di salsa di pesce
2 cucchiai di zucchero
200 ml di succo d'ananas
Sale, pepe
2 cipolle tagliate a dadini e sbollentate
120 g di arachidi tostate

Tagliate le cosce di anatra a pezzi grossi e lasciatele marinare con l'anice stellato e la salsa di soia per almeno 2 ore. In un wok scaldate l'olio e friggetevi prima le patate poi i pezzi di anatra marinati per 4 minuti ciascuno. Fate sgocciolare la carne di anatra e le patate e mettetele da parte. Togliete l'olio dal wok e fatevi dorare la pasta di curry, le capsule di cardamomo, il bastoncino di cannella e le foglie di alloro insieme alla carne di anatra. Versatevi il latte di noce di cocco e la panna di cocco e lasciate crogiolare per ca. 20 minuti. Insaporite con salsa di pesce, zucchero e succo d'ananas, salate e pepate. Aggiungetevi le patate a dadini, le cipolle e le arachidi. Servite con riso.

Cocoon Restaurant

Design: Stephane Dupoux | Chef: Andrew Lassetter
Owner: Ignite Group Ltd

65 Regent Street | London, W1B 4EA | Mayfair
Phone: +44 20 7494 7600
www.cocoon-restaurants.com | info@cocoon-restaurants.com
Tube: Piccadilly Circus
Opening hours: Mon–Fri noon to 3 pm, Mon–Wed 5:30 pm to 1 am,
Thu–Sat 5:30 pm to 3 am (late lounge from 11:30 pm), Sun closed
Average price: £40
Cuisine: Pan Asian – the best of Asia, Sushi, Dim Sum, Wok

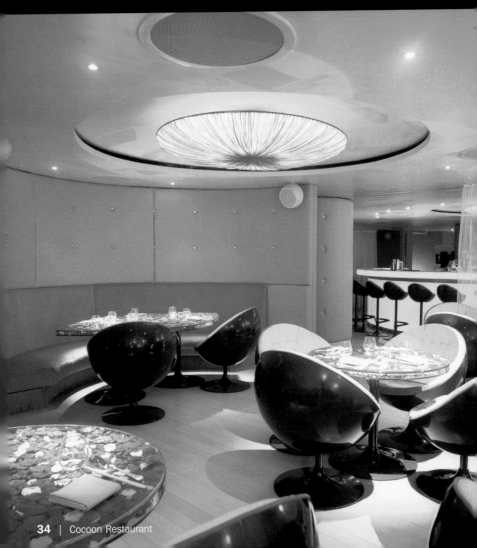

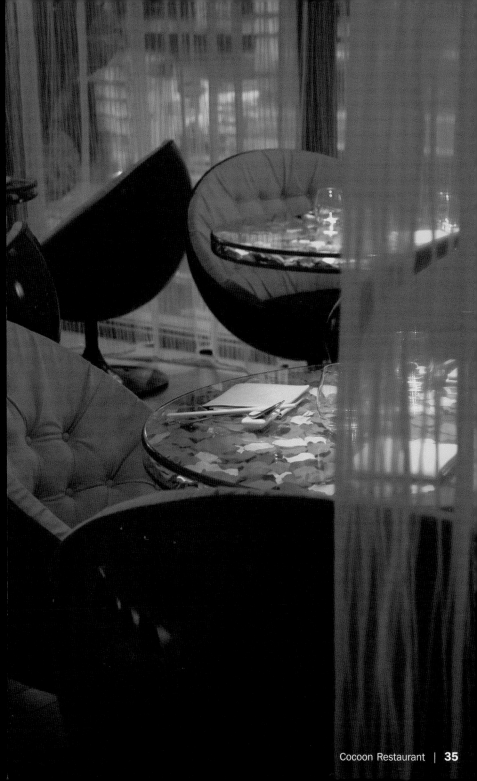

Criterion Grill

Chef: Roger Pizey | Owner: Marco Pierre White

224 Piccadilly | London, W1J 9HP | Mayfair
Phone: +44 20 7930 0488
www.whitestarline.org.uk
Tube: Piccadilly Circus
Opening hours: Lunch Mon–Sat noon to 2:30 pm, dinner Mon–Sat 5:30 pm to 11 pm
Average price: £30
Cuisine: French with Mediterranean influences
Special features: Available for private hire

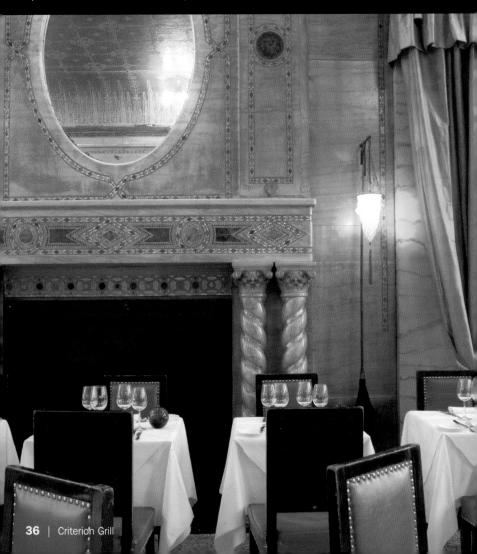

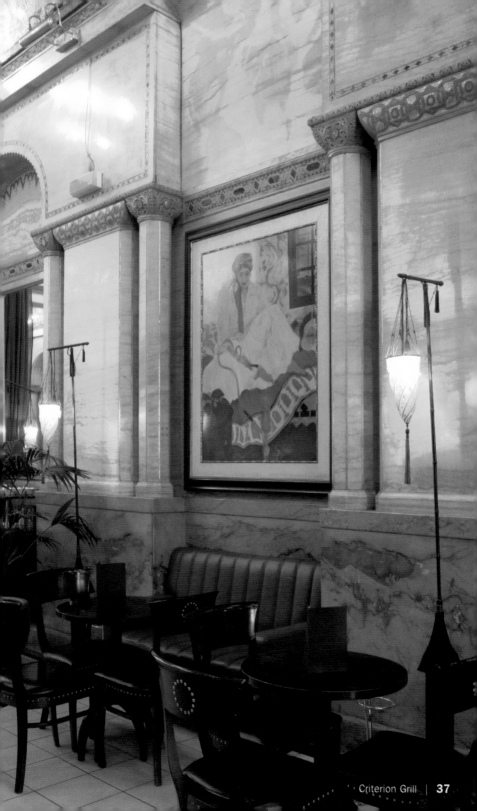

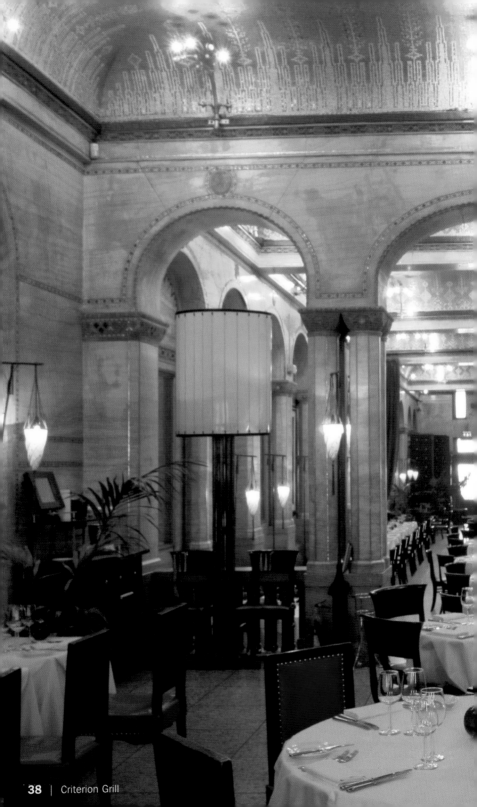

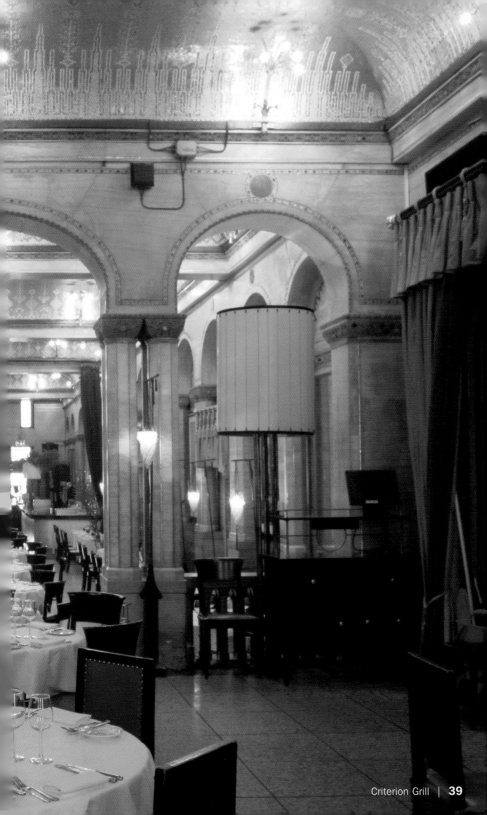

15 Westland Place | London, N1 7LP | Islington
Phone: +44 870 787 1515 | 0871 330 1515
www.fifteenrestaurant.com
Tube: Old Street
Opening hours: Lunch noon to 2:30 pm, dinner 6:30 pm to 9:30 pm
Menu price: £70
Cuisine: Modern Mediterranean

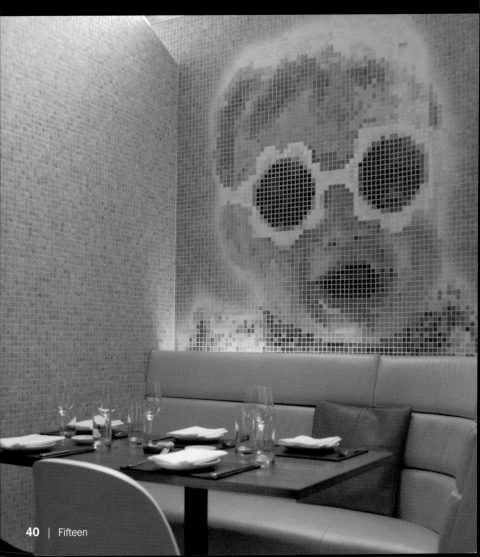

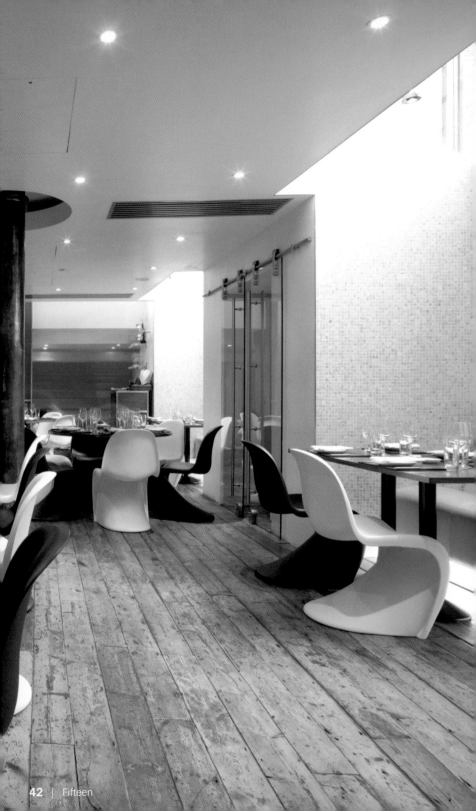

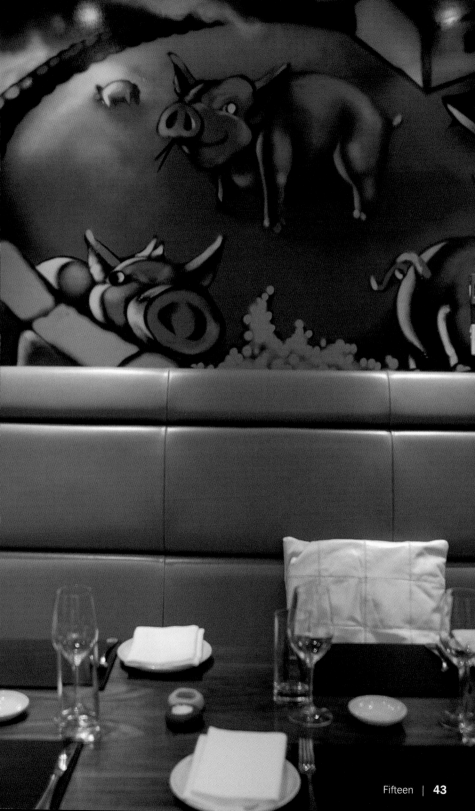

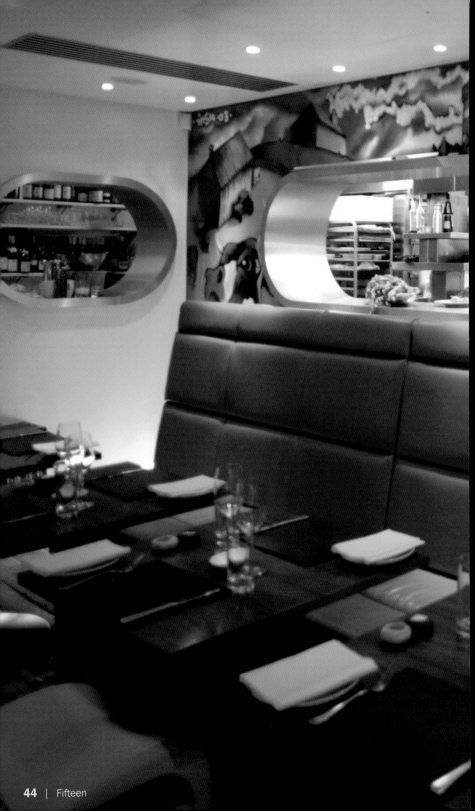

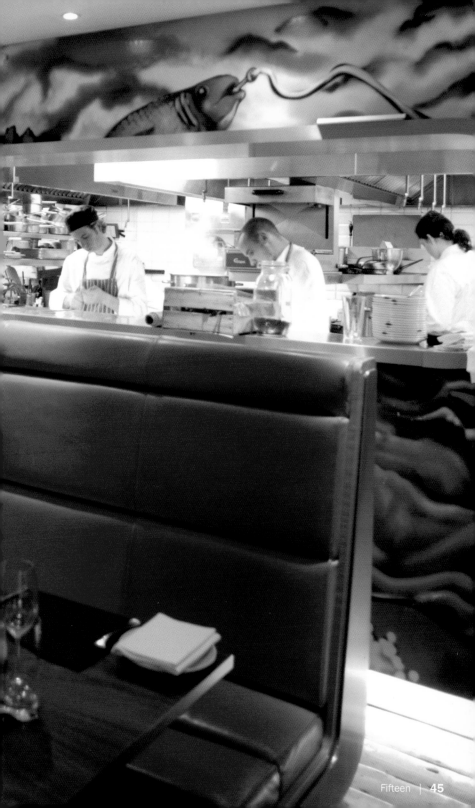

Christmas Salad

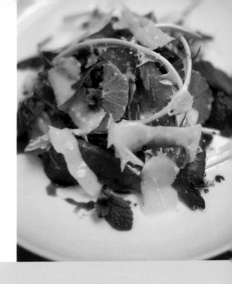

Weihnachtssalat

Salade de Noël

Ensalada de Navidad

Insalata di Natale

12 slices of Speck
1 bunch of watercress
1 bunch of white dandelion or rocket
A few leaves of treviso
4 clementines
Good balsamic vinegar
Good olive oil
Parmesan cheese

Trim and wash the watercress if it needs it and with a pair of scissors, trim the dandelion or rocket and add it to the same bowl with the treviso. Carefully peel the clementines, keeping them whole, and slice them into thin slices. Add the sliced clementines to the salad leaves and dress with olive oil, a splash of balsamic vinegar, salt and pepper. Divide the salad between four plates and tuck three pieces of Speck in amongst the salad leaves. Shave a few pieces of Parmesan cheese over the top and drizzle with a little more balsamic vinegar and some extra virgin olive oil.

12 Scheiben Speck
1 Bund Brunnenkresse
1 Bund Löwenzahn oder Rucola
Ein paar Blätter Treviso-Salat
4 Klementinen
Balsamico, hochwertig
Olivenöl, hochwertig
Parmesankäse

Die Brunnenkresse waschen und gegebenenfalls stutzen. Anschließend den Löwenzahn oder den Rucola mit einer Schere zurechtschneiden und mit dem Treviso-Salat in eine Schüssel geben. Die Klementinen vorsichtig schälen, ohne sie zu beschädigen. Dann in dünne Scheiben schneiden. Die Klementinenscheiben mit den Salatblättern vermischen, mit Olivenöl anmachen, einen Schuss Balsamico-Essig hinzufügen und mit Salz und Pfeffer würzen. Den Salat auf vier Teller verteilen und jeweils drei Scheiben Speck zwischen den Salatblättern anrichten. Ein wenig Parmesankäse darüber reiben und mit ein paar Tropfen Balsamico-Essig und Olivenöl beträufeln.

12 tranches de lard
1 bouquet de cresson d'eau
1 bouquet de pissenlits blancs ou de roquette
Quelques feuilles de trévise
4 clémentines
Un bon vinaigre balsamique
Une huile d'olive de bonne qualité
Parmesan

Ecourtez et lavez le cresson d'eau si nécessaire, et, avec une paire de ciseaux, écourtez aussi les pissenlits ou la roquette et mettez ensuite leurs feuilles dans le même saladier que la trévise. Pelez soigneusement les clémentines en veillant à les laisser entières, puis découpez-les en tranches minces. Ajoutez les clémentines ainsi émincées aux feuilles de salade et apprêtez avec l'huile d'olive, un jet de vinaigre balsamique, du sel et du poivre. Répartissez la salade sur quatre assiettes et, sur chaque, placez trois morceaux de lard dans les feuilles de salade. Parsemez le parmesan sur le tout puis versez un filet supplémentaire de vinaigre balsamique et d'huile d'olive vierge extra.

12 lonchas de beicon
1 ramo de berros
1 ramo de diente de león o de rúcola
Unas cuantas hojas de chicoria trevisana
4 clementinas
Vinagre balsámico de buena calidad
Aceite de oliva de buena calida
Queso parmesano

Corte y lave, si es necesario, los berros y con unas tijeras corte el diente de león o la rúcola y póngalos junto con las hojas de chicoria en una ensaladera. Pele con cuidado las clementinas, dejándolas enteras y luego tájelas en rodajas finas. Agregue las rodajas de clementina a la ensalada y aderece con aceite de oliva, un chorrito de vinagre balsámico, sal y pimienta. Reparta la ensalada en cuatro platos y mezcle entre las hojas de la ensalada tres trozos de beicon. Ralle encima un poco de queso parmesano y rocíe con un poco de balsámico y de aceite de oliva.

12 fette di pancetta
1 mazzetto di crescione d'acqua
1 mazzetto di tarassaco o rucola
Qualche foglia di radicchio
4 clementine
Aceto balsamico di qualità
Olio d'oliva di qualità
Parmigiano

Lavate il crescione d'acqua e, se necessario, spuntatene le foglie. Poi, servendovi di forbici, tagliate il tarassaco o la rucola a pezzetti della misura desiderata e metteteli in un'insalatiera assieme al radicchio. Sbucciate le clementine con cautela senza rovinarle. Tagliatele quindi a fette sottili. Unite le fette di clementine alle foglie d'insalata, condite con olio d'oliva, aggiungete uno spruzzo di aceto balsamico, salate e pepate. Distribuite l'insalata su quattro piatti e mettete su ogni piatto tre fette di pancetta sistemandole tra le foglie d'insalata. Grattugiatevi sopra un po' di parmigiano e versatevi alcune gocce di aceto balsamico e olio d'oliva.

Fifth Floor

Design: Lifschutz Davidson | Chef: Helena Puolakka
Owner: Harvey Nichols

Harvey Nichols, 109–125 Knightsbridge | London, SW1X 7RJ | Knightsbridge
Phone: +44 20 7235 5250
www.harveynichols.com | reception@harveynichols.com
Tube: Knightsbridge
Opening hours: Lunch Mon–Thu noon to 3 pm, Fri noon to 3:30 pm, Sat noon to
3 pm, 3:30 pm to 6 pm, Sun 11:30 am to 3:30 pm, dinner Mon–Sat 6 pm to 11 pm
Average price: £38
Cuisine: Modern European
Special features: The place to see and be seen

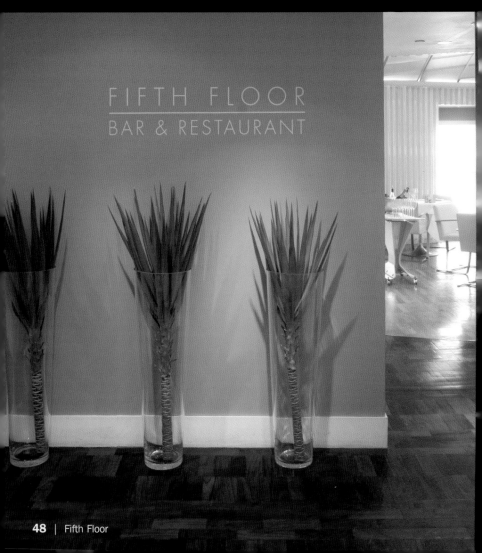

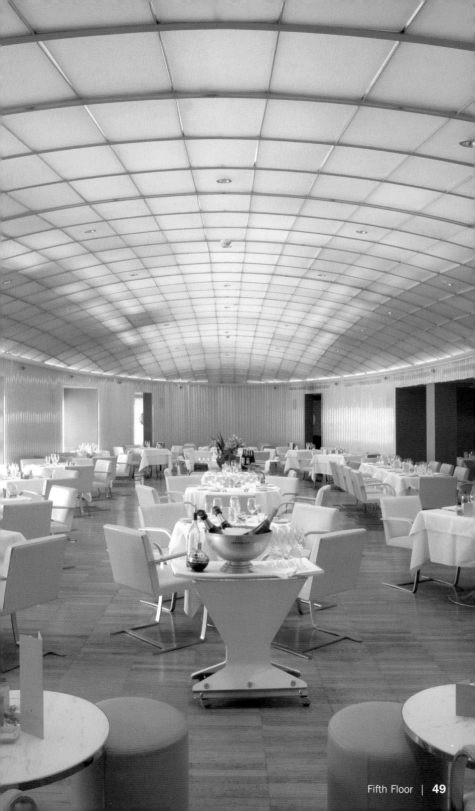

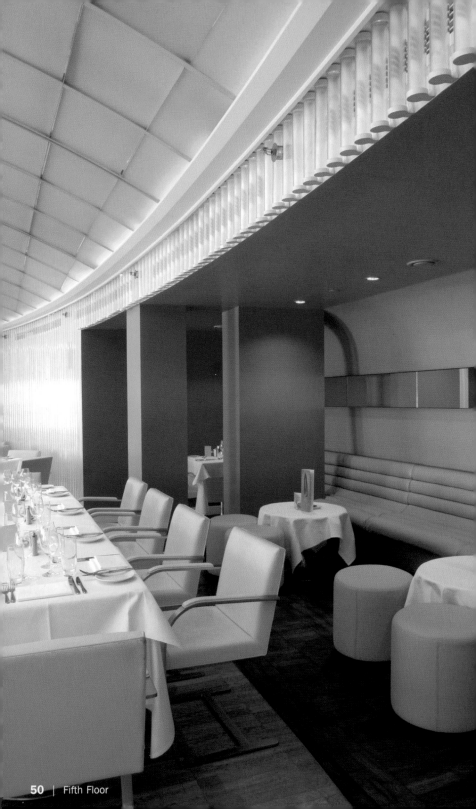

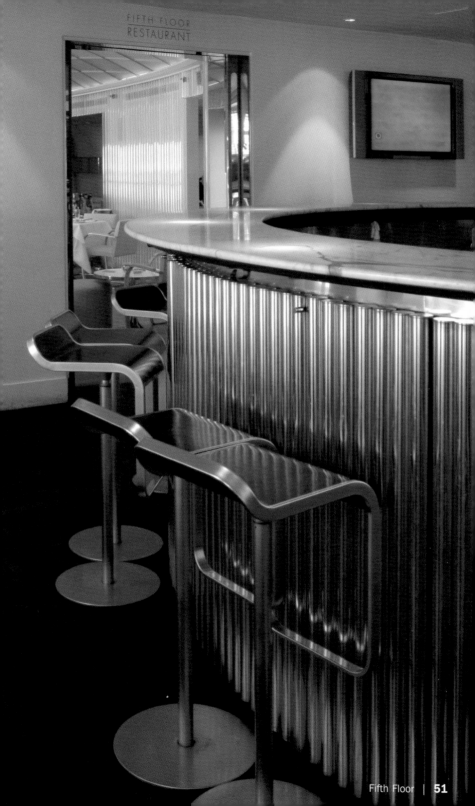

Stuffed Baby-Squid

Gefüllter Baby-Tintenfisch

Petit calamar farci

Chipirones rellenos

Calamaretto farcito

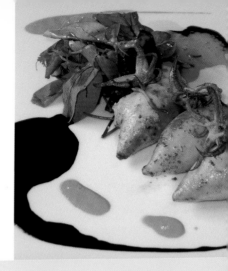

8 baby-squid tubes, cleaned
7 oz ham, diced finely
1 leek, diced finely
2 shallots, diced finely
2 tbsp olive oil
1 tsp lemon peel, diced finely
2 tbsp mascarpone
3 tbsp parmesan, grated
2 egg yolks
1 pinch curry
Salt, pepper
8 tooth picks
Oil for frying

Sauté shallots in olive oil until golden brown and chill. Combine all ingredients, season and stuff into squid tubes. Close each tube with one tooth pick and sear in olive oil from all sides. Before serving let rest on a warm place for 5 minutes.

8 Baby-Tintenfischmäntel, geputzt
200 g Schinken, fein gewürfelt
1 Lauch, fein gewürfelt
2 Schalotten, fein gewürfelt
2 EL Olivenöl
1 TL Zitronenschale, fein gewürfelt
2 EL Mascarpone
3 EL Parmesan, gerieben
2 Eigelbe
1 Prise Curry
Salz, Pfeffer
8 Zahnstocher
Öl zum Braten

Die Schalotten in dem Olivenöl goldbraun braten und abkühlen lassen. Alle Zutaten mischen, abschmecken und in die Tintenfischmäntel füllen. Jeden Tintenfisch mit einem Zahnstocher verschließen und in Olivenöl von allen Seiten anbraten. Vor dem Servieren an einem warmen Ort 5 Minuten ruhen lassen.

8 petits blancs d'encornets nettoyés
200 g de jambon en petits dés
1 poireau en petits dés
2 échalotes en petits dés
2 c. à soupe d'huile d'olive
1 c. à café de zeste de citron en petits dés
2 c. à soupe de mascarpone
3 c. à soupe de parmesan râpé
2 jaunes d'oeufs
1 pincée de curry
Sel, poivre
8 cure dent
Huile pour la cuisson

Faire dorer les échalotes dans l'huile d'olive et laisser refroidir. Mélanger tous les ingrédients, assaisonner et en farcir les blancs d'encornets. Fermer les calamars avec un cure dent et les faire dorer de chaque côté dans de l'huile d'olive. Avant de servir, laisser reposer dans un endroit chaud pendant 5 minutes.

8 cuerpos de chipirones, limpios
200 g de jamón, en dados pequeños
1 puerro, en dados pequeños
2 chalotes, finamente troceados
2 cucharadas de aceite de oliva
1 cucharadita de piel de limón, finamente troceada
2 cucharadas de queso mascarpone
3 cucharadas de queso parmesano, rallado
2 yemas
1 pizca de curry
Sal, pimienta
8 palillos
Aceite para freír

Rehogue los chalotes en aceite de oliva hasta que se doren y déjelos después enfriar. Mezcle todos los ingredientes, sazónelos y rellene con ellos los chipirones. Ciérrelos después con un palillo y fríalos por todos los lados en aceite de oliva. Antes de servir deje que reposen en un sitio caliente durante 5 minutos.

8 mantelli di calamaretto puliti
200 g di prosciutto tagliato a dadini sottili
1 porro tagliato a dadini sottili
2 scalogni tagliati a dadini sottili
2 cucchiai di olio d'oliva
1 cucchiaino di scorza di limone tagliata a dadini sottili
2 cucchiai di mascarpone
3 cucchiai di parmigiano grattugiato
2 tuorli d'uovo
1 pizzico di curry
Sale, pepe
8 stecchini
Olio per rosolare

Fate cuocere gli scalogni nell'olio d'oliva finché saranno ben dorati e lasciateli raffreddare. Mescolate tutti gli ingredienti, correggete di sapore e farcitevi i mantelli di calamaretti. Chiudete ogni calamaretto con uno stecchino e fatelo rosolare in olio d'oliva da tutti i lati. Prima di servire, lasciate riposare in un luogo caldo per 5 minuti.

Fish!

Design: Julian Wickham, revamped by Paul Daly
Chef: Nick Melmoth Coombs | Owner: Tony Allan

Cathedral Street, Borough Market | London, SE1 9AL | Southwark
Phone: +44 20 7407 3803
www.fishdiner.co.uk | borough@fishdiner.co.uk
Tube: London Bridge
Opening hours: 11 am to 11:30 pm
Average price: £25
Cuisine: Seafood

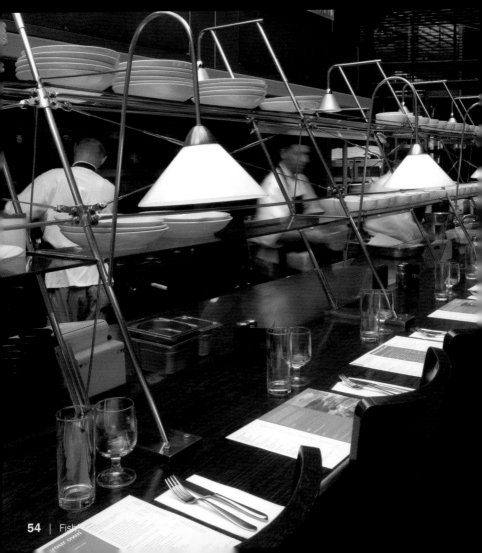

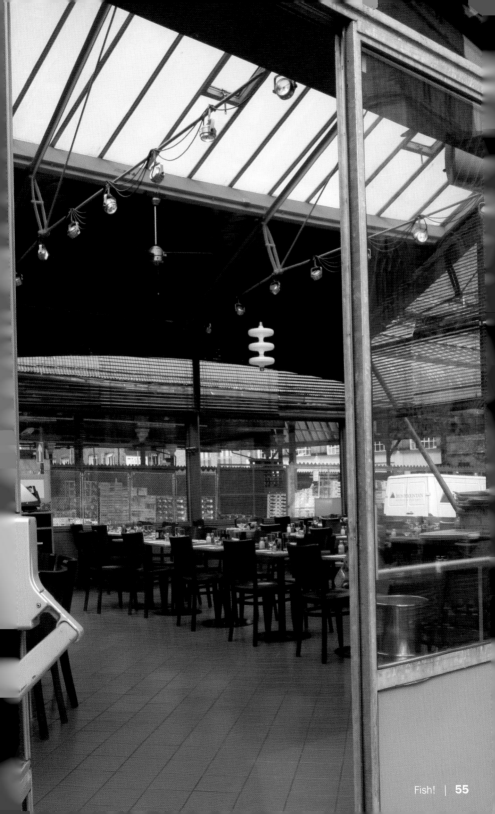

Food @ The Muse

Design: Bednarski Studio Design | Owner: Mukesh Patel

269 Portobello Road | London, W11 1LR | Notting Hill
Phone: +44 20 7792 1111
www.foodatthemuse.co.uk | manager@foodatthemuse.co.uk
Tube: Notting Hill Gate, Ladbroke Grove
Opening hours: Mon–Fri 11 am to 11 pm, Sat 10 am to 11 pm, Sun 10 am to 6 pm
Average price: £25
Cuisine: Based on taste and flavor exploring hot, sweet, salt and sour
Special features: Working studios for fine arts graduates, available for private hire,
cross section of all the arts

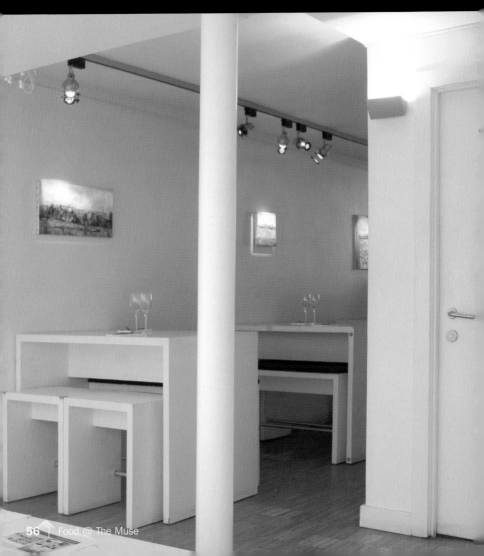

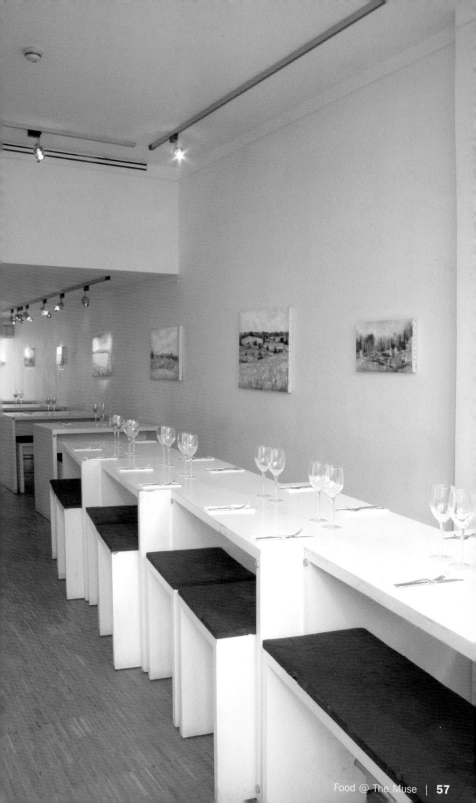

Grilled Tuna
with Sesame and Asia-Vinaigrette

Gegrillter Thunfisch mit Sesam und Asia-Vinaigrette

Thon grillé au sésame et à la vinaigrette asiatique

Atún a la parrilla con sésamo y vinagreta Asia

Tonno alla piastra con sesamo e vinaigrette Asia

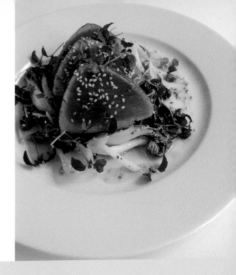

13 oz tuna
1 tsp ground cinnamon
Salt, pepper
2 tbsp sesame oil
10 oz bok choy, cut in wide stripes
3 tbsp sesame oil

Asia-Vinaigrette:
1 tbsp rice vinegar
Juice and peel of one orange
1 pinch chili powder
1 tbsp soy sauce
1 tsp ginger, grated
Juice of one lime
Salt, pepper and sugar
2 tbsp sesame oil

3 tbsp roasted sesame seeds
Thai cress for decoration

Heat sesame oil in a wok and sauté bok choy until leaves have wilted. Combine all ingredients for the vinaigrette in a bowl and mix well. Season the tuna fillet with cinnamon, salt and pepper and sear from all sides for approx. 2 minutes in very hot sesame oil. Cut the tuna fillet into ½ inch slices and arrange with the bok choy. Drizzle with the Asia-Vinaigrette and sprinkle with sesame and Thai-cress.

400 g Thunfischfilet
1 TL Zimt
Salz, Pfeffer
2 EL Sesamöl
300 g Bok Choy, in breiten Streifen
3 EL Sesamöl

Asia-Vinaigrette:
1 EL Reisessig
Saft und Schale einer Orange
1 Prise Chilipulver
1 EL Sojasauce
1 TL Ingwer, gerieben
Saft einer Limette
Salz, Pfeffer und Zucker
2 EL Sesamöl

3 EL Sesam, geröstet
Thaikresse zur Dekoration

Sesamöl im Wok erhitzen und den Bok Choy anschwitzen, bis er zusammenfällt. Alle Zutaten für die Asia-Vinaigrette in eine Schüssel geben und gründlich mischen. Das Thunfischfilet mit Zimt, Salz und Pfeffer würzen und von allen Seiten ca. 2 Minuten in sehr heißem Sesamöl anbraten. Das Thunfischfilet in 1–2 cm starke Scheiben schneiden und auf dem Bok Choy anrichten. Mit der Asia-Vinaigrette beträufeln und mit geröstem Sesam und Thaikresse bestreuen.

400 g de filet de thon
1 c. à café de cannelle
Sel, poivre
2 c. à soupe d'huile de sésame
300 g de bok choy en larges tranches
3 c. à soupe d'huile de sésame

Vinaigrette asiatique :
1 c. à soupe de vinaigre de riz
Jus et écorce d'une orange
1 pincée de piment en poudre
1 c. à soupe de sauce de soja
1 c. à café de gingembre râpé
Jus d'un citron vert
Sel, poivre et sucre
2 c. à soupe d'huile de sésame

3 c. à soupe de graines de sésame grillées
Cresson thai pour la décoration

Réchauffer l'huile de sésame dans le wok, saisir et faire fondre le bok choy. Verser tous les ingrédients de la vinaigrette asiatique dans une jatte et bien mélanger. Assaisonner le filet de thon avec la cannelle, le sel et le poivre et faire colorer sur tous les côtés env. 2 minutes dans l'huile de sésame très chaude. Couper le filet en tranches de 1 à 2 cm d'épaisseur et disposer sur le bok choy. Arroser de vinaigrette et décorer de graines de sésame grillées et de cresson thai.

400 g de filete de atún
1 cucharadita de canela
Sal, pimienta
2 cucharadas de aceite de sésamo
300 g de bok choy, en tiras anchas
3 cucharadas de aceite de sésamo

Vinagreta Asia:
1 cucharada de vinagre de arroz
El zumo y la piel de una naranja
1 pizca de guindilla molida
1 cucharada de salsa de soja
1 cucharadita de jengibre, rallada
El zumo de una lima
Sal, pimienta y azúcar
2 cucharadas de aceite de sésamo

3 cucharadas de semillas de sésamo, tostadas
Berros thai para decorar

Caliente el aceite de sésamo en un wok y rehogue dentro el bok choy hasta que esté pochado. Ponga todos los ingredientes en un cuenco para preparar la vinagreta y mézclelos bien. Sazone el atún con la canela, la sal y la pimienta por los dos lados y fríalo durante aprox. 2 minutos en aceite de sésamo muy caliente. Corte el filete en tiras de 1-2 cm de ancho y póngalas en los platos junto con el bok choy. Aliñe con la vinagreta y esparza por encima las semillas de sésamo tostadas y los berros thai.

400 g di filetto di tonno
1 cucchiaino di cannella
Sale, pepe
2 cucchiai di olio di sesamo
300 g di bok choi a strisce larghe
3 cucchiai di olio di sesamo

Vinaigrette Asia:
1 cucchiaio di aceto di riso
Succo e scorza di un'arancia
1 pizzico di chili in polvere
1 cucchiaio di salsa di soia
1 cucchiaino di zenzero grattugiato
Succo di una limetta
Sale, pepe e zucchero
2 cucchiai di olio di sesamo

3 cucchiai di sesamo tostato
Crescione tailandese per decorare

In un wok scaldate l'olio di sesamo e fatevi appassire il bok choi. Mettete in una ciotola tutti gli ingredienti per la vinaigrette Asia e mescolate accuratamente. Condite il filetto di tonno con la cannella, salatelo e pepatelo e fatelo cuocere da tutti i lati in olio di sesamo bollente per ca. 2 minuti. Tagliate il filetto di tonno a fette di 1-2 cm di spessore e disponetelo sul bok choi. Versatevi alcune gocce di vinaigrette Asia e cospargetelo con sesamo tostato e crescione tailandese.

Hakkasan

Design: Christian Liaigre | Chef: Tong Chee Hwee
Owner: Alan Yau

8 Hanway Place | London, W1T 9DH | Bloomsbury
Phone: +44 20 7927 7000
Tube: Tottenham Court Road
Opening hours: Lunch Mon–Fri noon to 3 pm, Sat–Sun noon to 4 pm,
dinner Sun–Wed 6 pm to 11 pm, Thu–Sat 6 pm to midnight
Average price: £45
Cuisine: Dim Sum, Chinese
Special features: Interior Design, Michelin prized

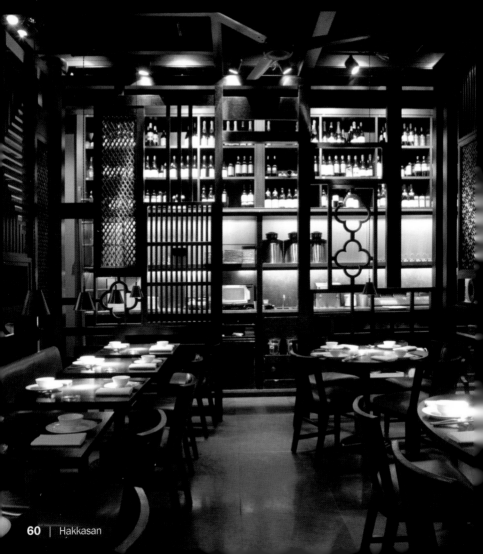

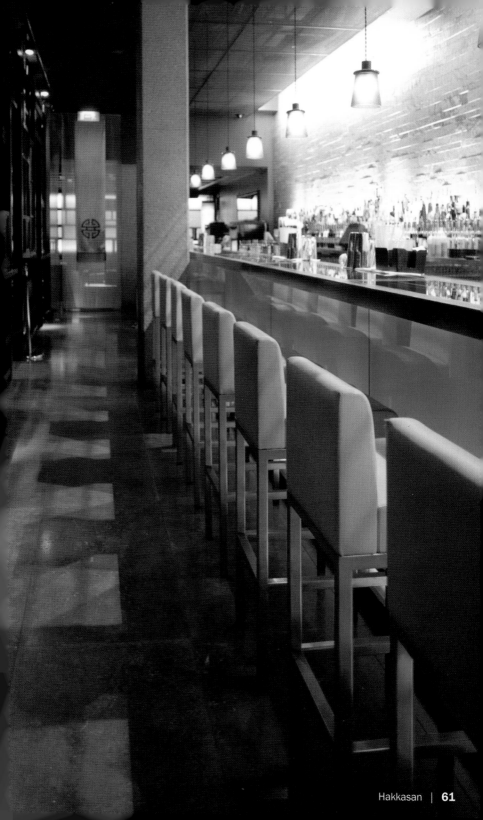

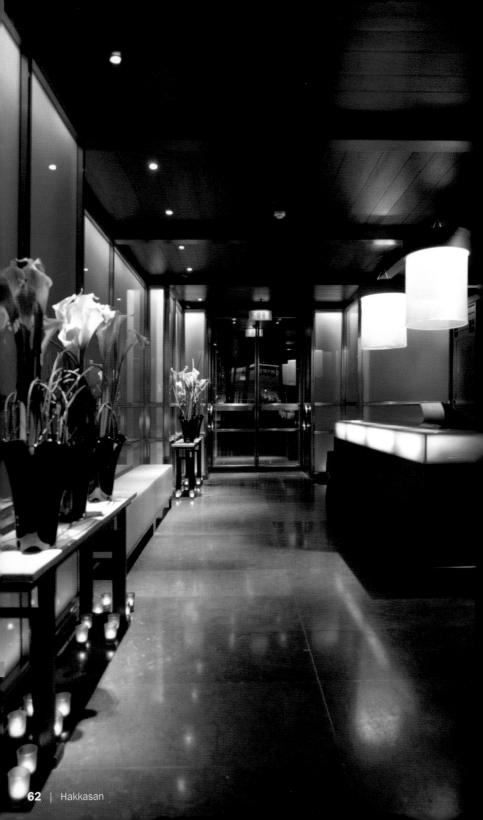

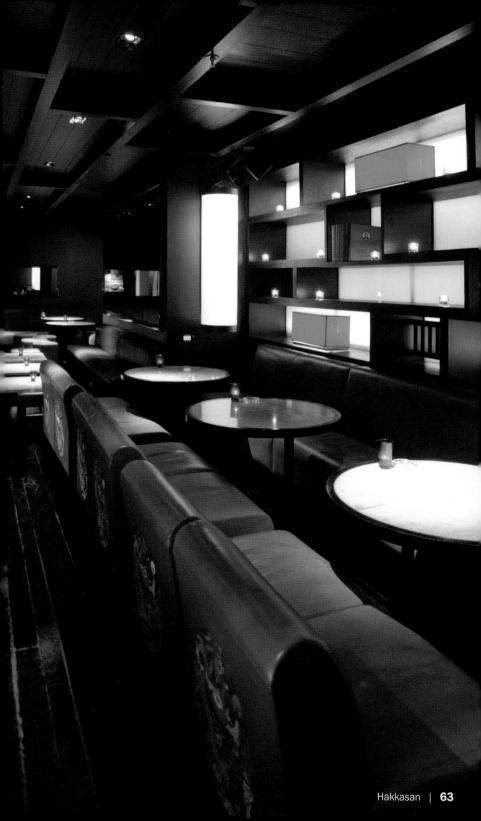

XO Silver Cod

XO Silberner Kabeljau

XO cabillaud argenté

XO bacalao plateado

Merluzzo argentato con salsa XO

4 silver cod fillets, 8 ½ oz each
Salt, pepper
Corn starch for dusting
Vegetable oil for frying

20 Thai asparagus, approx. 4 inches long, cleaned
1 l water
2 tbsp ginger, grated
1 tbsp corn starch
3 tbsp vegetable oil
1 clove of garlic, chopped
2 tbsp red chili, chopped finely
2 tbsp rice wine
175 ml soy sauce
120 ml XO sauce (special Asian seasoning sauce)
2 spring onions, in fine stripes
Salt, pepper

Cut each cod fillet into 1 inch-stripes, season with salt and pepper and dust with corn starch. Fry in very hot oil from both sides for 3 minutes, remove and set aside. Clean the wok, bring the water with the ginger to a boil and blanch the asparagus for approx. 3 minutes. Discard the water and sauté the asparagus with corn starch, salt and pepper. Set aside. Clean the wok again, sauté the garlic and chili in little oil, fill up with rice wine and soy sauce and place the fish back in the wok. Carefully cook for 1 minute, then add the XO sauce and the spring onions and cook for another minute. Arrange the asparagus diagonally on a plate, place the fish stripes on top and drizzle with some of the sauce from the wok. Garnish with fresh onion rings and chilis.

4 Silberner Kabeljaufilets à 250 g
Salz, Pfeffer
Maisstärke zum Bestäuben
Pflanzenöl zum Braten

20 Stangen Thai-Spargel, ca. 10 cm lang, geputzt
1 l Wasser
2 EL Ingwer, gerieben
1 EL Maisstärke
3 EL Pflanzenöl
1 Knoblauchzehe, gehackt
2 EL rote Chili, fein gehackt
2 EL Reiswein
175 ml Sojasauce
120 ml XO Sauce (spezielle Asia-Würzsauce)
2 Frühlingszwiebeln, in feinen Streifen
Salz, Pfeffer

Jedes Kabeljaufilet in ca. 3 cm breite Streifen schneiden, mit Salz und Pfeffer würzen und mit Maisstärke bestäuben. In sehr heißem Öl von beiden Seiten 3 Minuten anbraten, herausnehmen und beiseite stellen. Den Wok säubern, das Wasser mit dem Ingwer im Wok erhitzen und den Spargel ca. 3 Minuten blanchieren. Das Wasser abgießen und den Spargel mit der Stärke, Salz und Pfeffer anschwitzen. Herausnehmen. Den Wok wieder säubern, den Knoblauch und die Chili in etwas Öl anschwitzen, mit Reiswein und Sojasauce ablöschen und den Fisch zurück in den Wok geben. 1 Minute vorsichtig köcheln lassen, dann die XO Sauce und die Frühlingszwiebeln zugeben und eine weitere Minute köcheln lassen. Den Spargel schräg auf einer Platte anrichten, die Fischstreifen darauf legen und mit etwas Sauce aus dem Wok beträufeln. Mit frischen Zwiebelringen und Chilis garnieren.

4 filets de cabillaud argenté de 250 g chacun
Sel, poivre
Fécule de maïs pour saupoudrer
Huile végétale pour la cuisson

20 asperges thaïlandaises d'env. 10 cm de long
nettoyées
1 l d'eau
2 c. à soupe de gingembre râpé
1 c. à soupe de fécule de maïs
3 c. à soupe d'huile végétale
1 gousse d'ail hachée
2 c. à soupe de piment rouge finement haché
2 c. à soupe de vin de riz
175 ml de sauce de soja
120 ml de sauce XO (sauce condiment asiatique spéciale)
2 oignons printaniers en fines tranches
Sel, poivre

Couper chaque filet de cabillaud en lamelles d'env. 3 cm de large, saler, poivrer et saupoudrer de fécule de maïs. Faire colorer des deux côtés dans l'huile très chaude pendant 3 minutes, retirer et réserver. Nettoyer le wok, faire chauffer l'eau avec le gingembre dans le wok et blanchir les asperges env. 3 minutes. Verser l'eau et faire revenir les asperges avec la fécule, le sel et le poivre. Réserver. Nettoyer de nouveau le wok, faire revenir l'ail et le piment dans un peu d'huile, déglacer avec le vin de riz et la sauce de soja et remettre le poisson dans le wok. Laisser mijoter prudemment 1 minute, ajouter ensuite la sauce XO et les oignons printaniers et laisser mijoter encore 1 minute. Disposer les asperges en travers d'un plat, y déposer les lamelles de poisson et arroser avec un peu de sauce du wok. Garnir de rondelles d'oignon frais et de piment.

4 filetes de bacalao plateado de 250 g cada uno
Sal, pimienta
Almidón de maíz para espolvorear
Aceite vegetal para freír

20 troncos de espárragos thai, limpios
1 l de agua
2 cucharadas de jengibre, rallado
1 cucharada de almidón de maíz
3 cucharadas de aceite vegetal
1 diente de ajo, picado
2 cucharadas de guindilla roja, finamente picada
2 cucharadas de vino de arroz
175 ml de salsa de soja
120 ml de salsa XO (salsa condimentada asiática especial)
2 cebolletas, en juliana
Sal, pimienta

Corte los filetes en tiras de aprox. 3 cm de ancho, salpiméntelas y espolvoree por encima el almidón de maíz. Fríalas en aceite muy caliente durante 3 minutos por cada lado, sáquelas y reserve. Limpie el wok, caliente el agua con el jengibre y escalde dentro los espárragos durante aprox. 3 minutos. Vierta el agua y rehogue los espárragos con el almidón, la sal y la pimienta. Saque los ingredientes. Limpie nuevamente el wok, rehogue el ajo y la guindilla en un poco de aceite, añada el vino de arroz y la salsa de soja y vuelva a introducir el pescado. Deje que se cueza a fuego lento durante 1 minuto, incorpore la salsa XO y las cebolletas. Cueza durante 1 minuto más. Coloque los espárragos en una bandeja, ponga encima las tiras de pescado y vierta un poco de la salsa del wok. Decore con aros de cebolleta fresca y guindillas.

4 filetti di merluzzo argentato da 250 g l'uno
Sale, pepe
Amido di mais da spolverare
Olio vegetale per rosolare

20 asparagi tailandesi interi, lunghi ca. 10 cm e puliti
1 l di acqua
2 cucchiai di zenzero grattugiato
1 cucchiaio di amido di mais
3 cucchiai di olio vegetale
1 spicchio d'aglio tritato
2 cucchiai di peperoncino rosso tritato finemente
2 cucchiai di vino di rizo
175 ml di salsa di soia
120 ml di salsa XO (particolare salsa aromatica asiatica)
2 cipollotti a listarelle sottili
Sale, pepe

Tagliate ogni filetto di merluzzo argentato a strisce di ca. 3 cm di larghezza, salatele e pepatele e spolveratele con amido di mais. Fatele rosolare in olio bollente da entrambi i lati per 3 minuti, toglietele e mettetele da parte. Pulite il wok, scaldatevi l'acqua con lo zenzero e sbollentatevi gli asparagi per ca. 3 minuti. Versate via l'acqua e fate dorare gli asparagi con l'amido di mais, il sale e il pepe. Togliete dal wok. Pulite di nuovo il wok, fatevi dorare l'aglio e il peperoncino in un po di olio, bagnate con il vino de rizo e la salsa di soia e rimettete il pesce nel wok. Lasciate crogiolare con cura per 1 minuto, aggiungete quindi la salsa XO e i cipollotti e lasciate crogiolare per un altro minuto. Sistemate gli asparagi di traverso su un piatto grande, disponetevi sopra le strisce di pesce e versatevi alcune gocce di salsa dal wok. Guarnite con rondelle di cipollotti e con peperoncino.

Mo*vida

Design: Samy Chams | Chef: Emiliano Musa
Owners: Marc Merran, Fred Moss, Samy Sass

8–9 Argyll Street | London, W1F 7TF | Soho
Phone: +44 20 7734 5776
www.movida-club.com
Tube: Oxford Circus
Opening hours: Wed–Sat 8 pm to 3:30 am
Average price: £35
Cuisine: Italian, French, English
Special features: Designer-dressed hosts and hostesses, celeb hangout

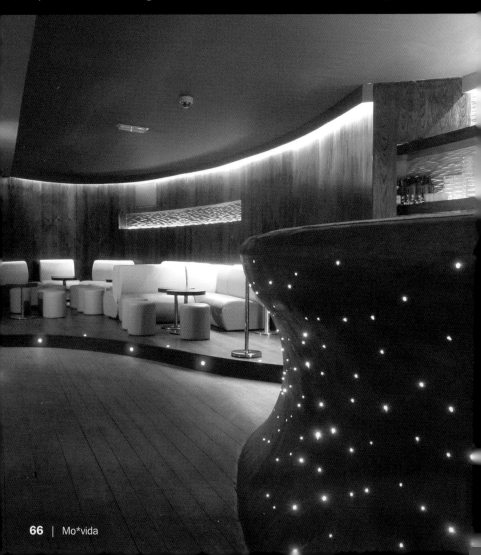

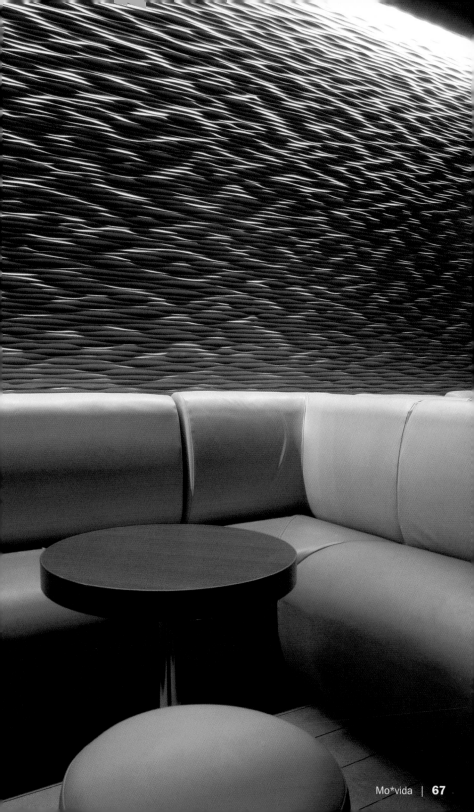

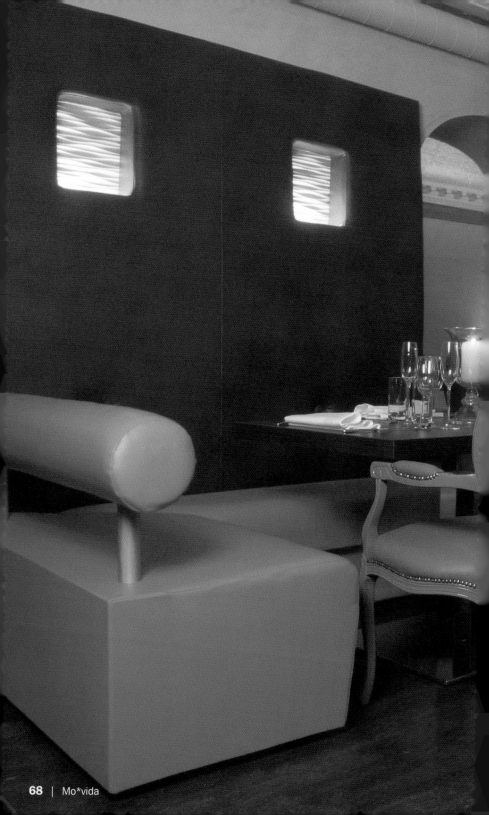

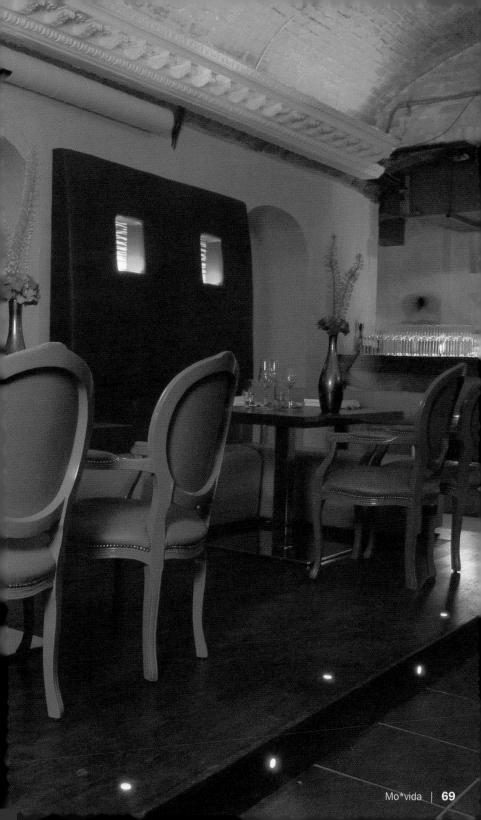

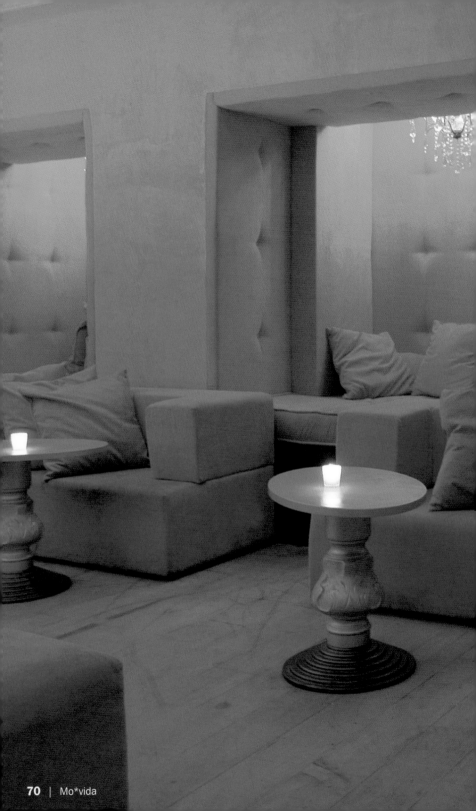

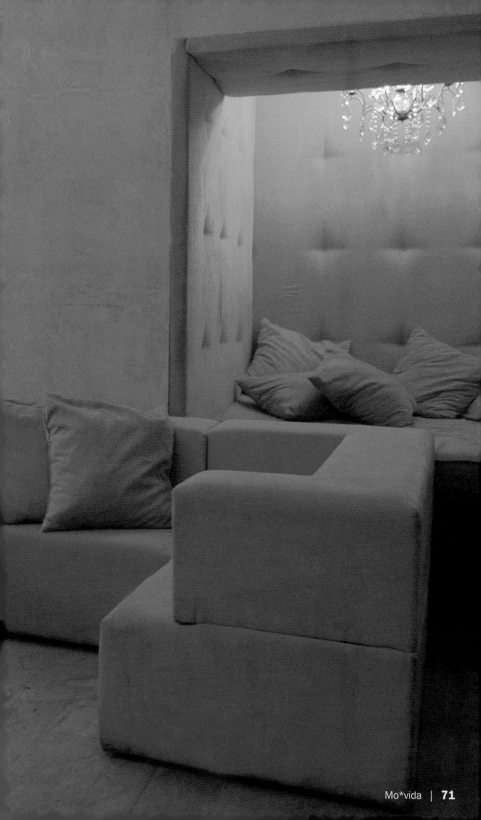

Design: Michaelisboyd | Chefs: Sam and Sam Clark
Owners: Sam and Sam Clark, Mark Sainsbury

34–36 Exmouth Market | London, EC1R 4QE | Finsbury
Phone: +44 20 7833 8336
www.moro.co.uk | info@moro.co.uk
Tube: Farringdon, Angel
Opening hours: Lunch Mon–Fri 12:30 pm to 2:30 pm, Sat 12:30 pm to 3 pm,
dinner Mon–Sat 7 pm to 10:30 pm
Average price: £35
Cuisine: African, Moroccan, Spanish

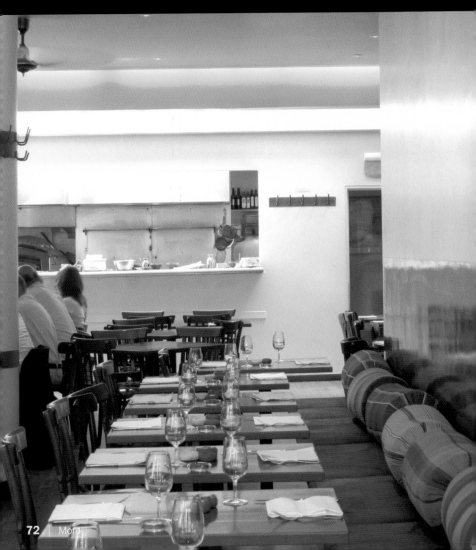

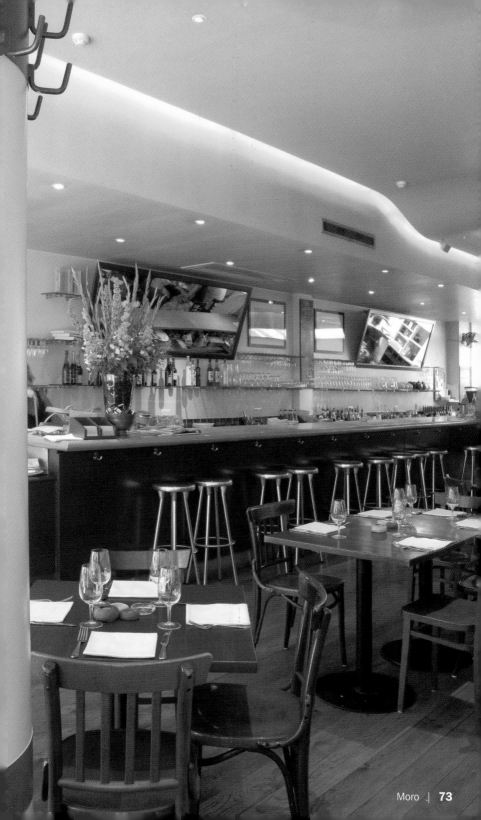

Nicole's

Design: Nicole Farhi | Chef: Annie Wayte | Owner: Stephen Marks

158 New Bond Street | London, W1S 2UB | Mayfair
Phone: +44 20 7499 8408
www.nicolefarhi.com
Tube: Bond Street, Green Park
Opening hours: Breakfast Mon–Sat 10 am to 11:30 am, lunch Mon–Sat noon to 3:30 pm, bar menu Mon–Sat 11:30 am to 5:30 pm, dinner Mon–Fri 6:30 pm to 10:45 pm
Average price: £20
Cuisine: Mediterranean, Modern European
Special features: In store restaurant

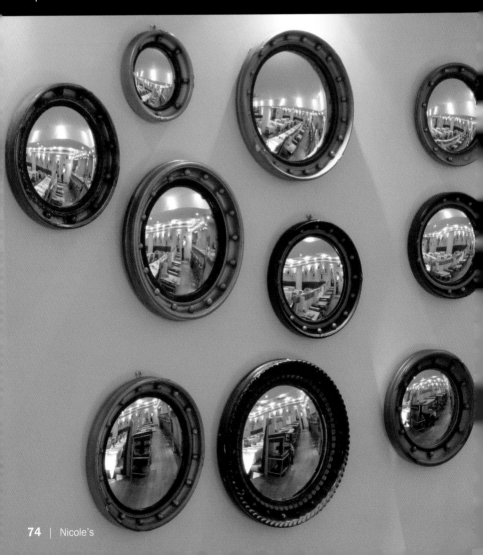

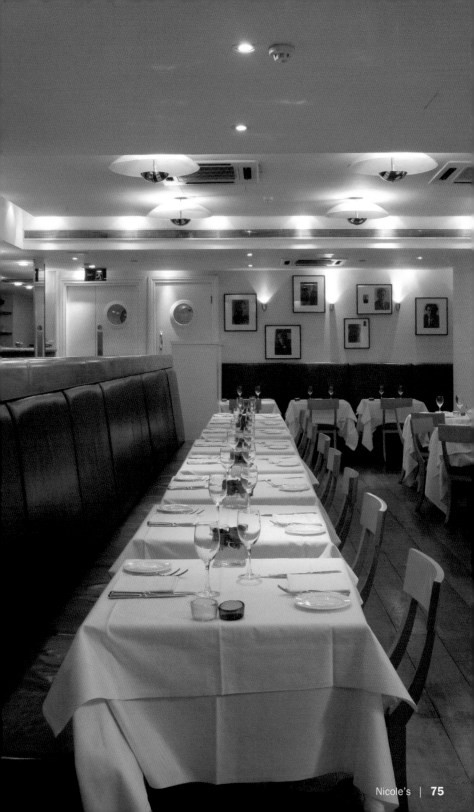

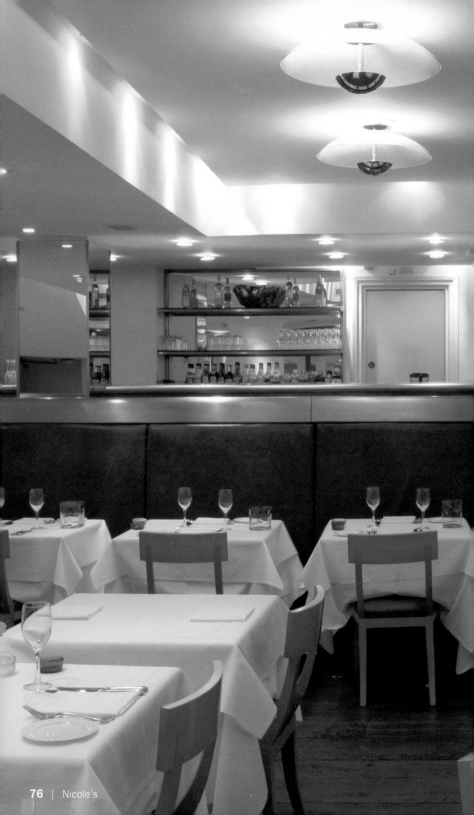

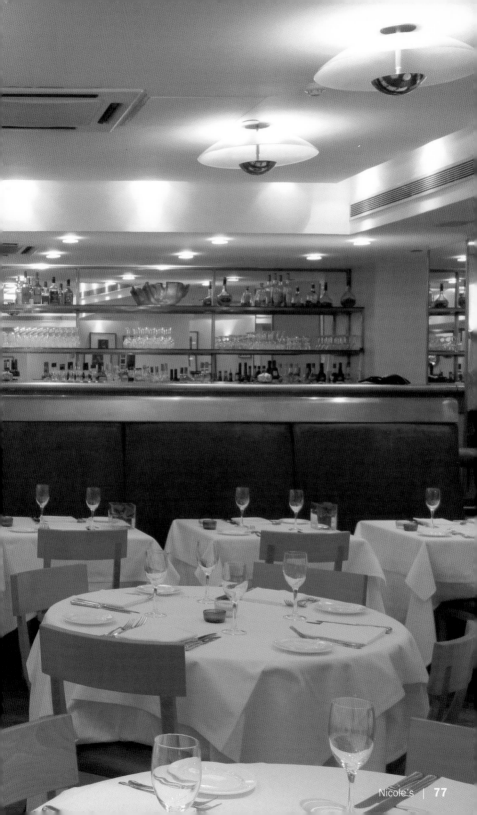

Fried Scallops
with Chorizo

Gebratene Jakobsmuscheln mit Chorizo

Coquilles Saint-Jacques rôties au chorizo

Vieiras asadas con chorizo

Capesante in padella con chorizo

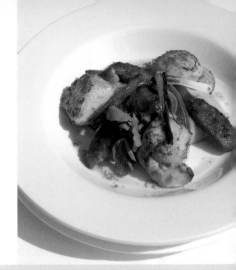

2 yams
2 large onions, sliced
2 tsp olive oil
Salt, pepper
1 clove of garlic
Peel from 2 limes
1 green chili, cleaned
1 tsp sweet paprika powder
3 ½ oz soft butter
4 chorizos, cut in half diagonally
8 spring onions, cleaned
12 scallops, cleaned
1 bunch water cress

Bake the yams at 390 °F for approx. 25 minutes, remove from the oven, chill and peel. Mash with salt and pepper. Keep warm. Season the onion rings and drizzle with olive oil. Place with the yams in the oven. Place garlic, lime peel, chili and paprika powder in a mortar and crush into a fine paste. Mix with the soft butter and season for taste. Fry chorizos and spring onions until golden brown. Fry the scallops in the lime-chili-butter for 2 minutes on each side and season. Spoon yam puree in the middle of the plates, arrange scallops, chorizo pieces, onion rings and spring onions around it and drizzle with melted lime-chili-butter. Garnish with water cress.

2 Süßkartoffeln
2 große Zwiebeln, in Scheiben
2 TL Olivenöl
Salz, Pfeffer
1 Knoblauchzehe
Schale von 2 Limetten
1 grüne Chilischote, entkernt
1 TL Paprikapulver
100 g weiche Butter
4 Chorizos (spanische Paprikasalami), schräg halbiert
8 Frühlingszwiebeln, geputzt
12 Jakobsmuscheln
1 Bund Brunnenkresse

Die Süßkartoffeln bei 200 °C ca. 25 Minuten backen, herausnehmen, abkühlen lassen und schälen. Mit Salz und Pfeffer zu einem Püree verarbeiten. Warm stellen. Die Zwiebelringe würzen und mit Olivenöl beträufeln. Mit den Kartoffeln im Ofen garen. Knoblauchzehe, Limettenschale, Chilischote und Paprikapulver in einen Mörser geben und zu einer feinen Paste zerdrücken. Mit der weichen Butter mischen und abschmecken. Die Chorizos und Frühlingszwiebeln in einer Pfanne goldbraun anbraten. Die Jakobsmuscheln in der Limetten-Chili-Butter von jeder Seite 2 Minuten braten und würzen. Süßkartoffelpüree in die Mitte der Teller geben, die Jakobsmuscheln, Chorizostücke, Zwiebelringe und Frühlingszwiebeln darauf verteilen und mit etwas flüssiger Limetten-Chili-Butter beträufeln. Mit Brunnenkresse garnieren.

2 patates douces
2 gros oignons en rondelles
2 c. à café d'huile d'olive
Sel, poivre
1 gousse d'ail
Zeste de 2 limettes
1 piment vert sans pépins
1 c. à café de poudre de paprika
100 g de beurre ramolli
4 chorizos (saucisson espagnol au piment doux)
coupés en deux en biais
8 oignons printaniers nettoyés
12 coquilles Saint-Jacques
1 botte de cresson de source

Faire cuire les patates douces au four à 200 °C pendant env. 25 minutes, les sortir, faire refroidir et peler. Les réduire en purée avec du sel et du poivre. Garder au chaud. Asperger les rondelles d'oignon de quelques gouttes d'huile d'olive. Les cuire au four avec les patates douces. Dans un mortier, écraser l'ail, le zeste de limette, le piment et la poudre de paprika en une fine pâte. Mélanger au beurre ramolli et rectifier l'assaisonnement. Faire dorer dans une poêle les chorizos et les oignons printaniers. Faire cuire les Saint-Jacques, avec le beurre de piment et de limette, 2 minutes de chaque côté et assaisonner. Déposer la purée de patates douces au centre des assiettes, répartir les Saint-Jacques, les morceaux de chorizo, les rondelles d'oignons et les oignons printaniers et verser un peu de beurre de piment et de limette liquide. Garnir de cresson de source.

2 patatas dulces
2 cebollas grandes, en rodajas
2 cucharaditas de aceite de oliva
Sal, pimienta
1 diente de ajo
La piel de 2 limas
1 guindilla verde, despepitada
1 cucharadita de pimentón
100 g de mantequilla blanda
4 chorizos, cortados por la mitad diagonalmente
8 cebolletas, limpias
12 vieiras
1 manojo de berros de agua

Ase las patatas en el horno durante 25 minutos a 200 °C, sáquelas, déjelas enfriar y pélelas. Hágalas puré con sal y pimienta. Resérvelas en un lugar caliente. Condimente los aros de cebolla y vierta por encima aceite de oliva. Áselos en el horno junto con las patatas. Ponga el ajo, la piel de lima, la guindilla y el pimentón en un mortero y maje hasta conseguir una pasta fina. Añada la mantequilla blanda, remueva y condimente al gusto. Fría el chorizo y las cebolletas en una sartén hasta que se doren. Fría las vieiras en la mantequilla de lima y guindilla durante 2 minutos por cada lado. Ponga un poco del puré de patata en el centro de cada plato, reparta alrededor las vieiras, los trozos de chorizo, los aros de cebolla y las cebolletas. Vierta por encima un poco de la mantequilla líquida de lima y guindilla. Decore con los berros.

2 patate dolci
2 cipolle grosse a rondelle
2 cucchiaini di olio d'oliva
Sale, pepe
1 spicchio d'aglio
Scorza di 2 limette
1 peperoncino verde privato dei semini
1 cucchiaino di paprica
100 g di burro ammorbidito
4 chorizo (salame piccante spagnolo) tagliato a metà di traverso
8 cipollotti puliti
12 capesante
1 mazzetto di crescione d'acqua

Cuocote le patate dolci in forno caldo a 200 °C per ca. 25 minuti, toglietele, lasciatele raffreddare e pelatele. Aggiungetevi sale e pepe e riducetele in purea. Mettete in caldo. Condite le rondelle di cipolla e versatevi alcune gocce di olio d'oliva. Mettetele a cuocere in forno con le patate. Mettete lo spicchio d'aglio, la scorza di limetta, il peperoncino e la paprica in un mortaio e schiacciate fino ad ottenere una pasta fine. Mescolatela al burro ammorbidito e correggete di sapore. In una padella fate rosolare i chorizo e i cipollotti finché saranno ben dorati. Friggete le capesante nel burro alla limetta e al peperoncino per 2 minuti per lato e conditele. Mettete il purè di patate dolci al centro dei piatti, distribuitevi sopra le capesante, i pezzi di chorizo, le rondelle di cipolla e i cipollotti e versatevi alcune gocce di burro liquido alla limetta e al peperoncino. Guarnite con crescione d'acqua.

Nobu Berkeley

Design: David Collins | Executive Chef: Mark Edwards
Owner: Nobu Matsuhisa

15 Berkeley Street | London, W1J 8DY | Mayfair
Phone: +44 20 7290 9222
www.noburestaurants.com
Tube: Green Park
Opening hours: Mon–Sat 6 pm to 2 am
Average price: £40
Cuisine: Japanese
Special features: Lounge bar, sushi bar

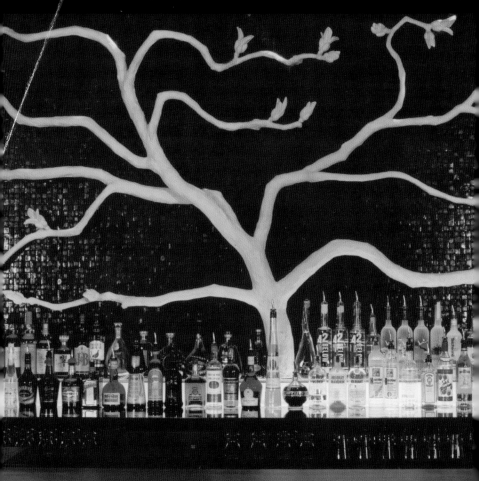

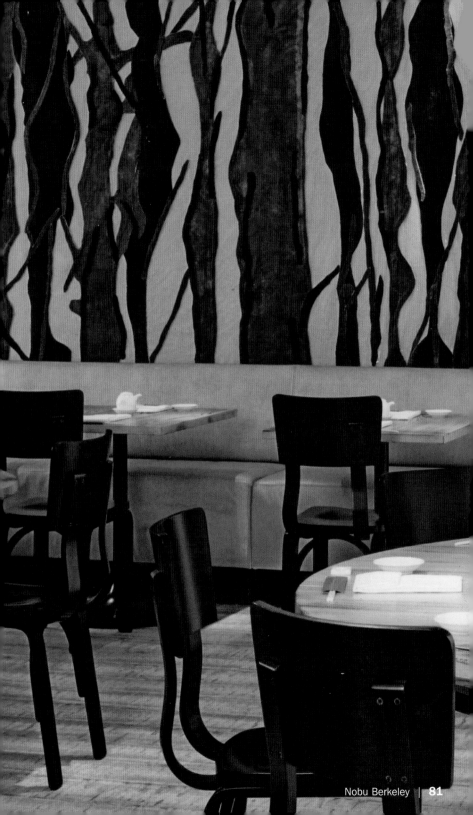

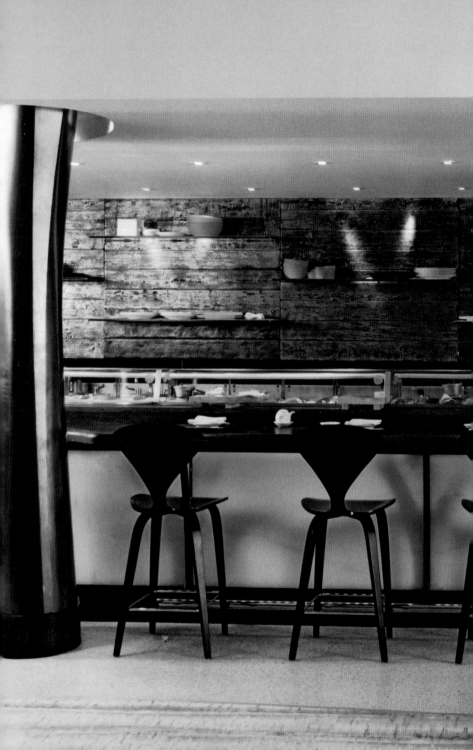

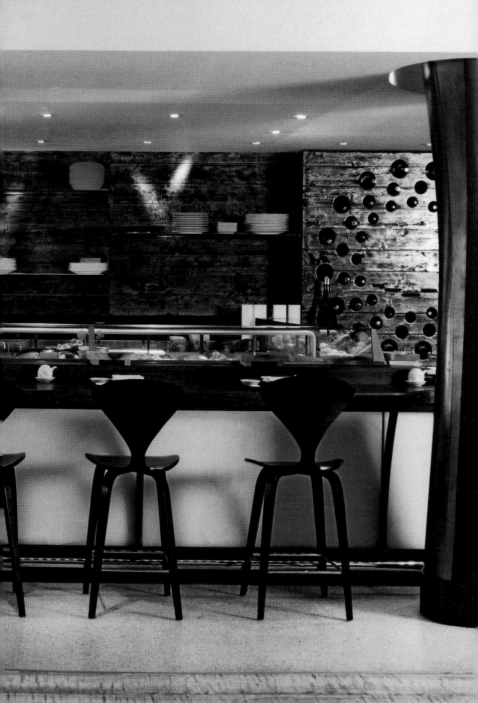

Pétrus

Design: David Collins | Executive Chef: Markus Wareing
Owner: Gordon Ramsay

Wilton Place | London, SW1X 7RL | Belgravia
Phone: +44 20 7235 1200
www.gordonramsay.com
Tube: Hyde Park Corner
Opening hours: Lunch Mon–Fri noon to 2:30 pm, dinner Mon–Sat 6 pm to 11 pm
Menu price: £70
Cuisine: French
Special features: Michelin prized

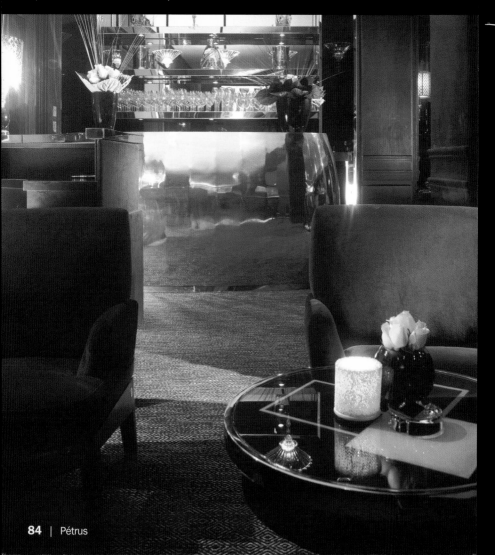

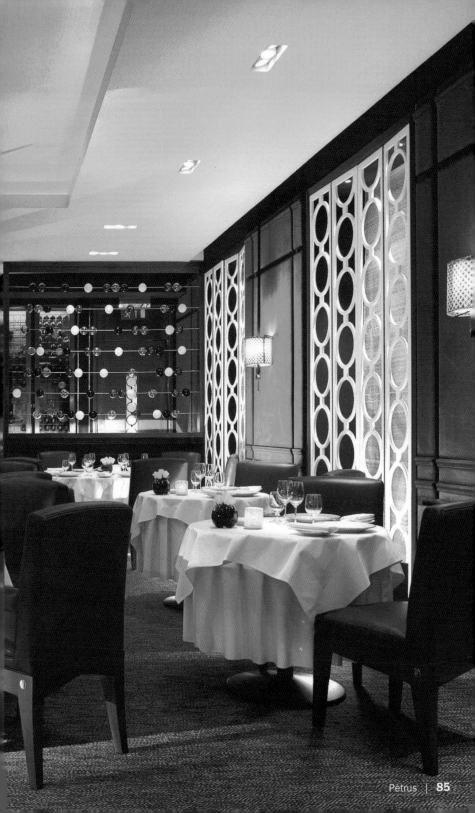

Plateau

Design: Conran & Partners | Head Chef: Tim Tolley

4th Floor, Canada Place | London, E14 4QS | Canary Wharf
Phone: +44 20 7715 7100
www.conran.com | plateau@conran-restaurants.co.uk
Tube: Canary Wharf
Opening hours: Lunch Mon–Fri noon to 3 pm, dinner Mon–Sat 6 pm to 11 pm,
bar & grill Mon–Sat noon to 11 pm, Sun 11 am to 4 pm
Average price: £40
Cuisine: Modern French

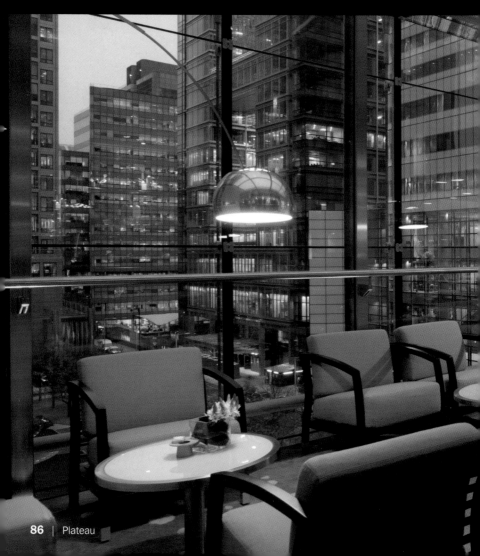

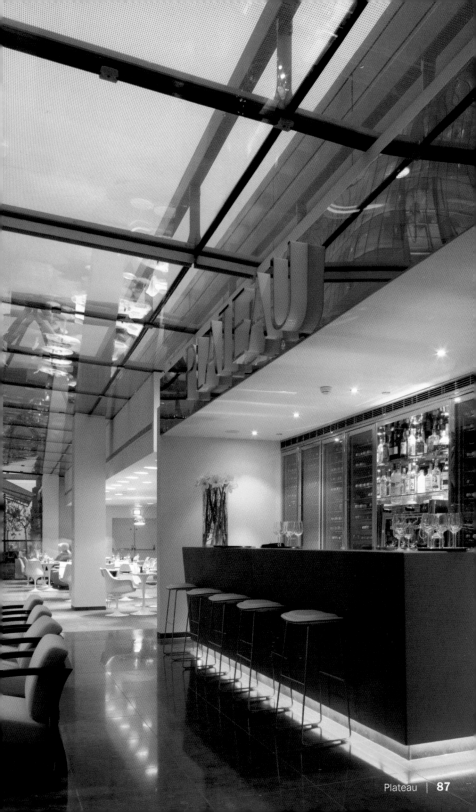

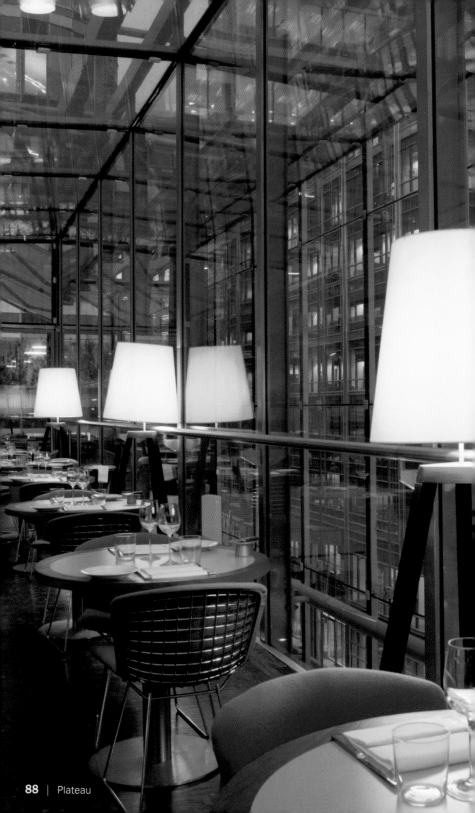

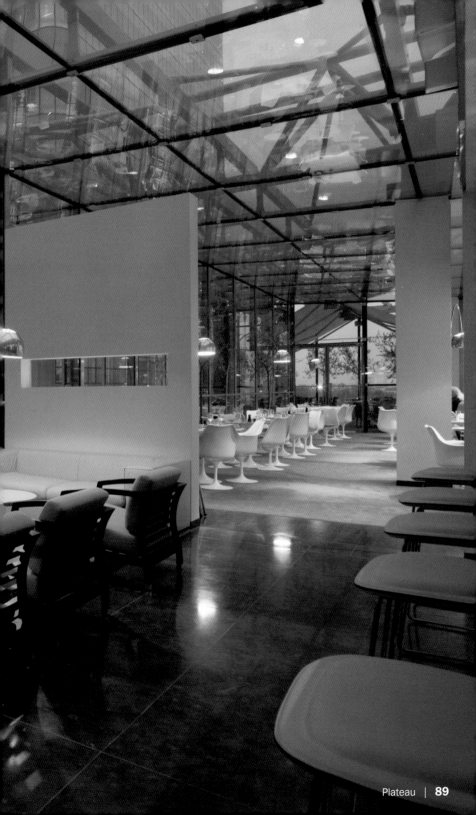

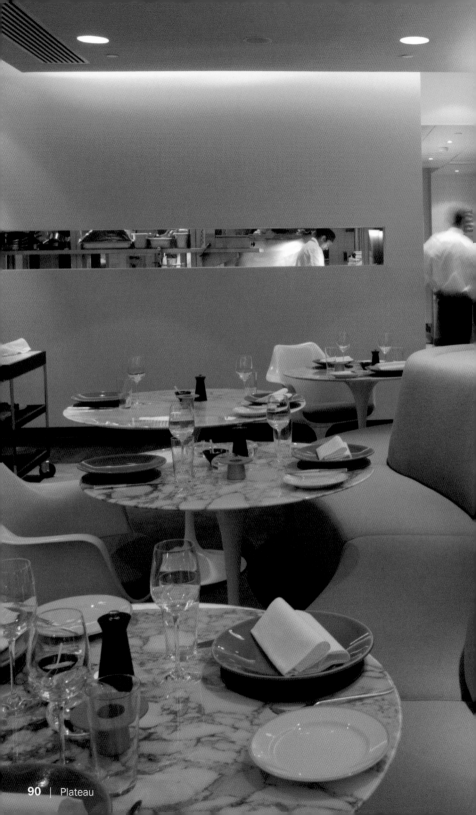

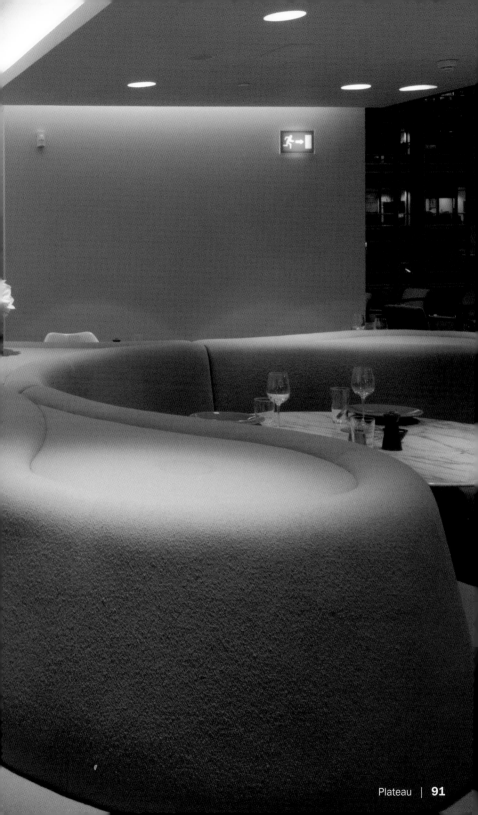

Chef: Brian Villahermosa

54 Goodge Street | London, W1T 4NA | Camden
Phone: +44 20 7637 0657
www.saltyard.co.uk | info@saltyard.co.uk
Tube: Goodge Street
Opening hours: Mon–Fri noon to 11 pm, Sat 5 pm to 11 pm
Average price: £15
Cuisine: Mediterranean
Special features: Outside seating, available for private hire

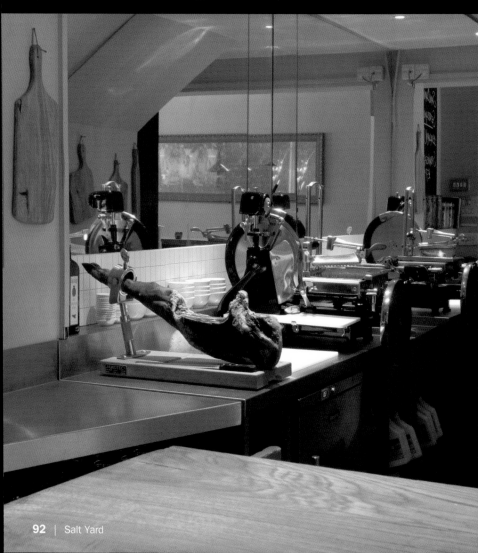

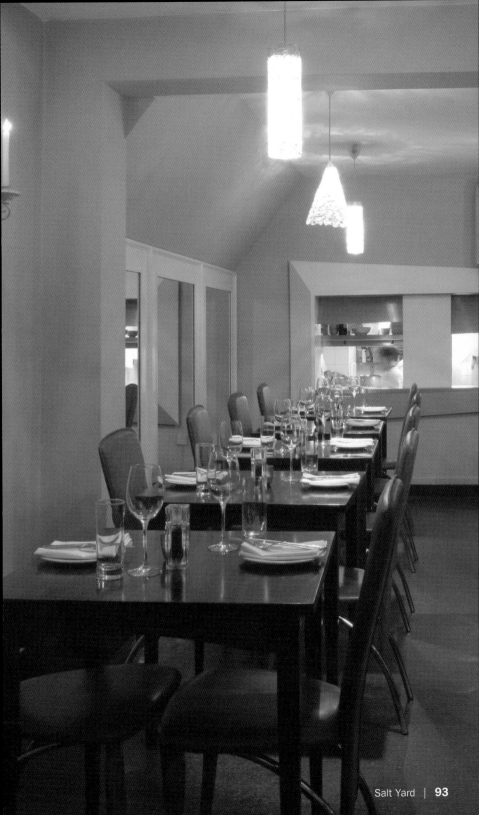

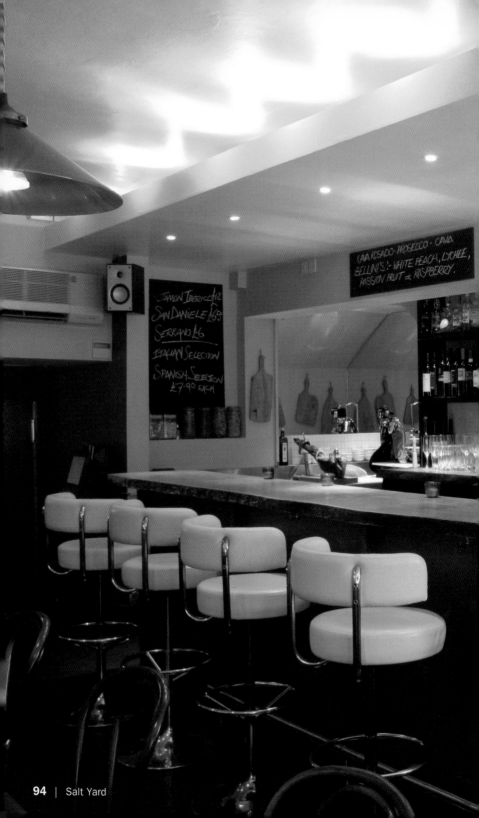

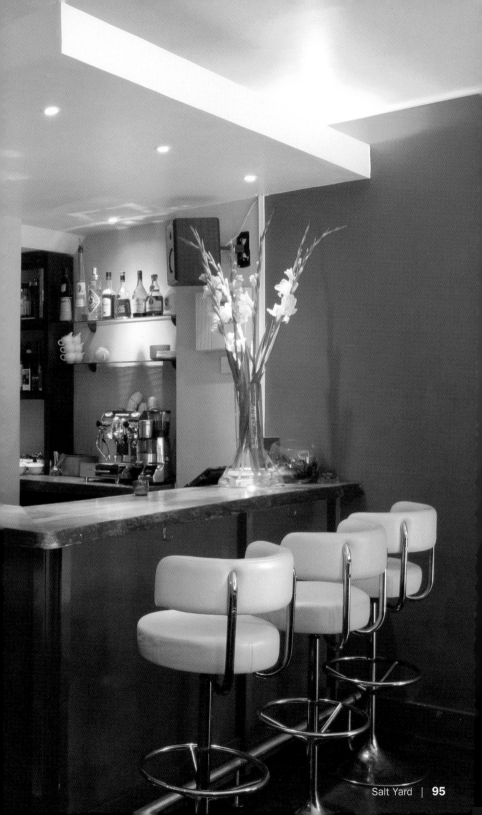

Fried Sea Brass

with Baby-Leek and Ajo-Blanco-Sauce

Gebratene Brasse mit Babylauch und Ajo-Blanco-Sauce

Brème grillée au poireau primeur et Ajo-Blanco-Sauce

Besugo asado con puerro y salsa ajo blanco

Sarago in padella con porro baby e salsa Ajo Blanco

2 ½ oz skinned almonds
1 clove of garlic
30 ml olive oil
300 ml ice cold water
1 oz white bread
Sherry-vinegar to season

Combine all ingredients in a food processor and mix until it resembles a creamy sauce. Strain, season and chill.

12 baby leek
4 tbsp roasted almonds, chopped
2 tbsp olive oil

Fry the baby leek in olive oil, season and mix with almonds. Keep warm.

4 sea brass fillets, 4 oz each
3 tbsp olive oil
Lemon juice
Salt, pepper

Season the brass fillets and fry in olive oil on the skin side for 3 minutes. Drizzle with lemon juice and arrange on the leek. Spoon sauce around the fillet and drizzle with olive oil.

80 g enthäutete Mandeln
1 Knoblauchzehe
30 ml Olivenöl
300 ml eiskaltes Wasser
30 g Weißbrot
Sherryessig zum Abschmecken

Alle Zutaten in einen Mixer geben und mixen bis eine cremige Sauce entsteht. Durch ein Sieb gießen, abschmecken und kaltstellen.

12 Stangen Babylauch, geputzt
4 EL geröstete Mandeln, gehackt
2 EL Olivenöl

Den Babylauch in Olivenöl anbraten, würzen und mit den Mandeln mischen. Warmstellen.

4 Brassenfilets à 120 g
3 EL Olivenöl
Zitronensaft
Salz, Pfeffer

Die Brassenfilets würzen und in Olivenöl au der Hautseite 3 Minuten braten. Mit etwas Zitronensaft beträufeln und auf dem Lauch anrichten. Die Sauce um das Filet gießen und mit Olivenöl garnieren.

80 g d'amandes émondées
1 gousse d'ail
30 ml d'huile d'olive
300 ml d'eau glacée
30 g de pain blanc
Vinaigre de sherry pour l'assaisonnement

Mettre tous les ingrédients dans un mixeur et mixer jusqu'à obtention d'une sauce crémeuse. Passer au chinois, rectifier l'assaisonnement et mettre au frais.

12 poireaux primeurs nettoyés
4 c. à soupe d'amandes grillées hachées
2 c. à soupe d'huile d'olive

Faire revenir le poireau primeur dans l'huile d'olive, assaisonner et ajouter les amandes. Conserver au chaud.

4 filets de brème de 120 g chacun
3 c. à soupe d'huile d'olive
Jus de citron
Sel, poivre

Assaisonner les filets de brème et les faire griller 3 minutes côté peau. Arroser de quelques gouttes de jus de citron et déposer sur le poireau. Verser l'ajo blanco autour du filet et garnir d'huile d'olive.

80 g de almendras peladas
1 diente de ajo
30 ml de aceite de oliva
300 ml de agua helada
30 g de pan blanco
Vinagre de jerez para sazonar

Ponga todos los ingredientes en la batidora y bátalos hasta conseguir una salsa cremosa. Pase la salsa por un colador, sazónela y resérvela en el frigorífico.

12 tallos de puerros pequeños, limpios
4 cucharadas de almendras tostadas, picadas
2 cucharadas de aceite de oliva

Rehogue los puerros en aceite de oliva, condiméntelos y mézclelos con las almendras. Resérvelos calientes.

4 filetes de besugo de 120 g cada uno
3 cucharadas de aceite de oliva
Zumo de limón
Sal, pimienta

Salpimiente los filetes de besugo y fríalos por el lado de la piel durante 3 minutos en aceite de oliva. Vierta por encima un poco del zumo de limón y coloque los filetes encima de los puerros. Vierta por encima la salsa y decore con el aceite de oliva.

80 g di mandorle spellate
1 spicchio d'aglio
30 ml di olio d'oliva
300 ml di acqua gelida
30 g di pane bianco
Aceto di sherry per insaporire

Mettete tutti gli ingredienti in un frullatore e frullate fino ad ottenere una salsa cremosa. Passate in un colino, insaporite e mettete a raffreddare.

12 porri baby interi e puliti
4 cucchiai di mandorle tostate e tritate
2 cucchiai di olio d'oliva

Fate rosolare il porro baby nell'olio d'oliva, conditelo e mescolatelo alle mandorle. Mettete in caldo.

4 filetti di sarago da 120 g l'uno
3 cucchiai di olio d'oliva
Succo di limone
Sale, pepe

Condite i filetti di sarago e friggeteli nell'olio d'oliva dalla parte della pelle per 3 minuti. Versatevi alcune gocce di succo di limone e sistemateli sul porro. Versate la salsa intorno al filetto e guarnite con olio d'oliva.

Sketch

Design: Mourad Mazouz, Gabban O'Keefe, Noe Duchaufour Lawrance,
Marc Newson, Chris Levine & Vincent Le Roy | Chef: Pierre Gagnaire

9 Conduit Street | London, W1S 2XG | Mayfair
Phone: +44 870 777 4488
www.sketch.uk.com
Tube: Oxford Circus
Opening hours: The Lecture Room and Library lunch Tue–Fri noon to 5 pm,
dinner Tue–Sat 7 pm to 10:30 pm, The Gallery Mon–Sat 7 pm to 2 am
Average price: The Gallery £40, The Lecture Room and Library £125
Cuisine: New French

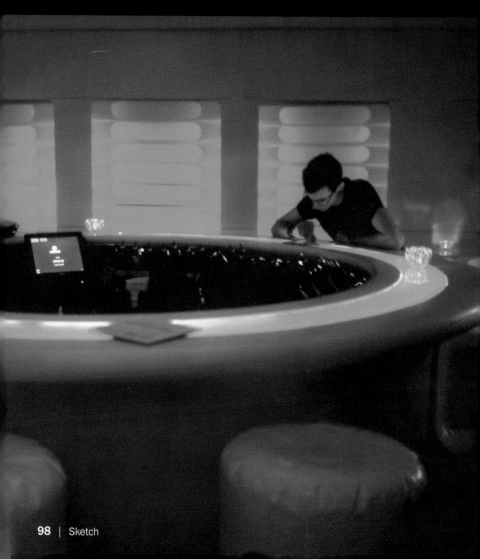

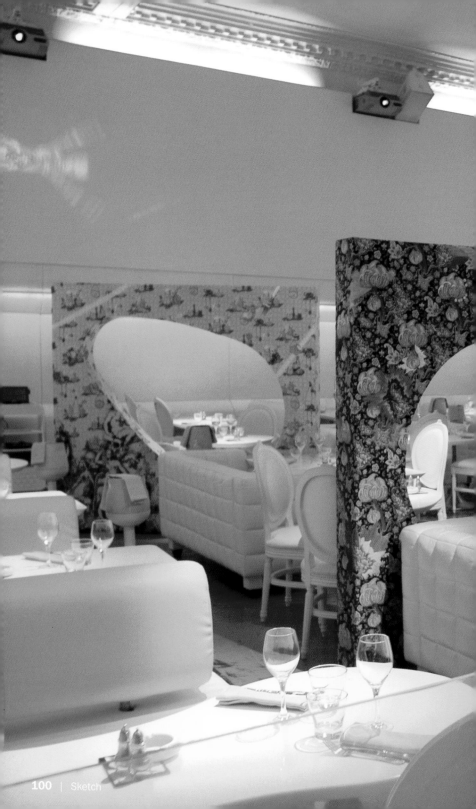

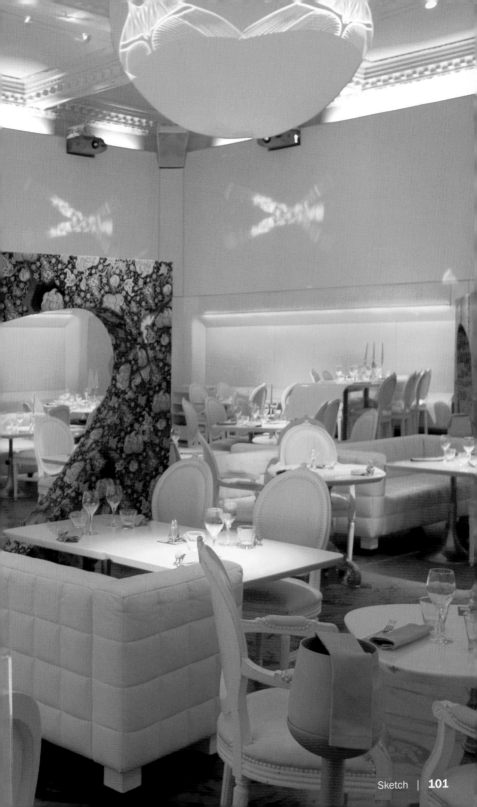

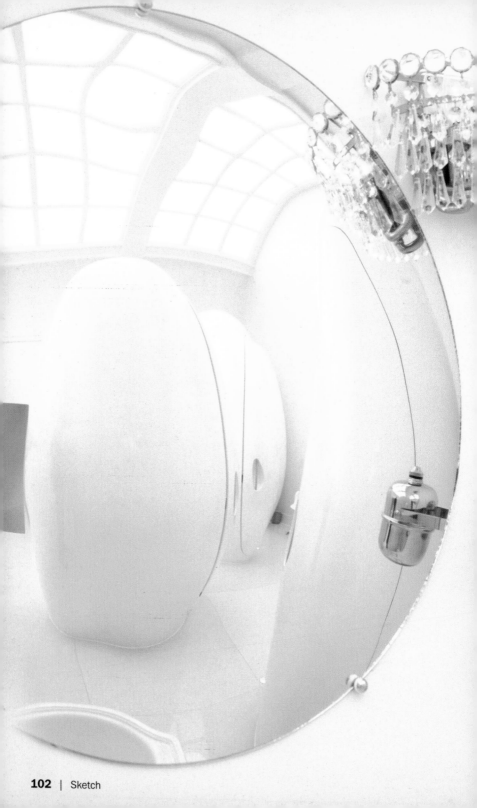

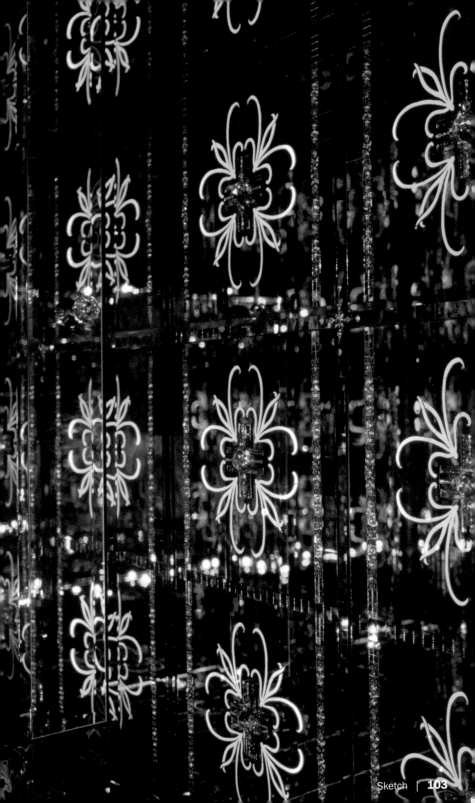

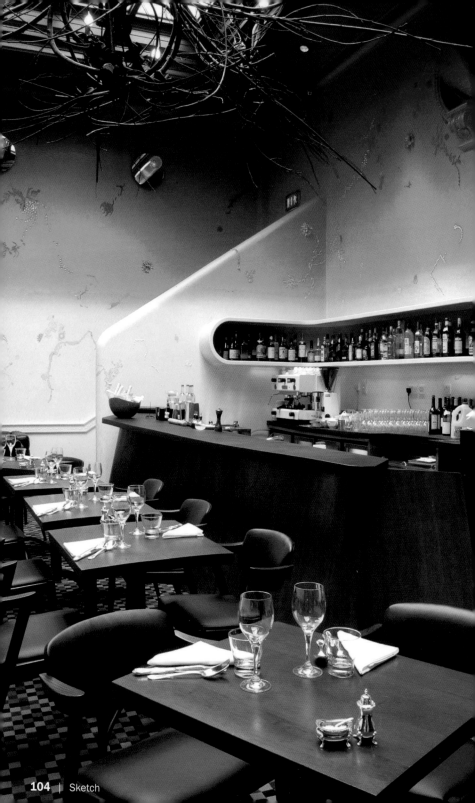

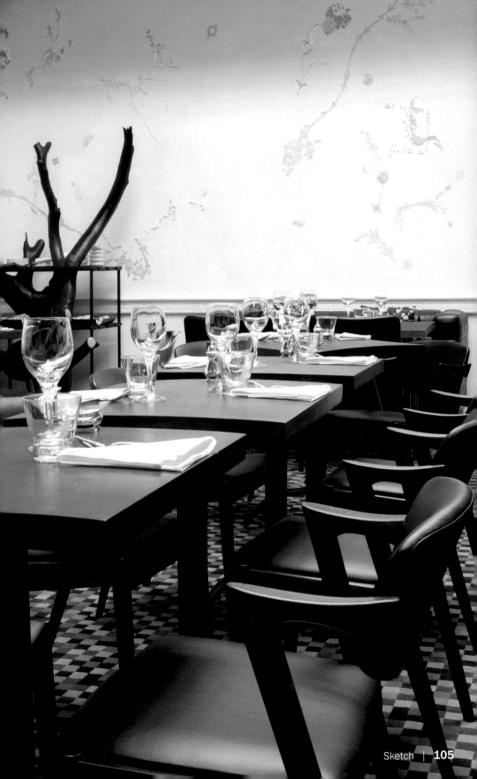

The Admiral Codrington

Design: Nina Campbell, www.ninacampbell.com
Chef: Jon Rotheram | Owners: Joel Cadbury, Longshot Plc

17 Mossop Street | London, SW3 2LY | Chelsea
Phone: +44 20 7581 0005
www.theadmiralcodrington.co.uk
Tube: South Kensington
Opening hours: Mon–Sat 11 am to 11 pm, Sun 11 am to 10:30 pm
Average price: £20
Cuisine: Modern European
Special features: Private dining, open roof, small outside seating

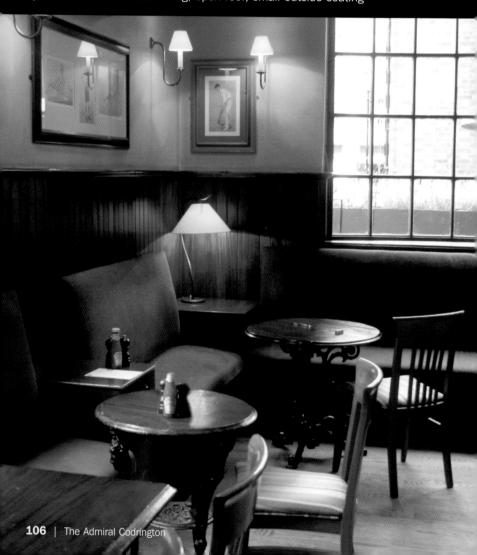

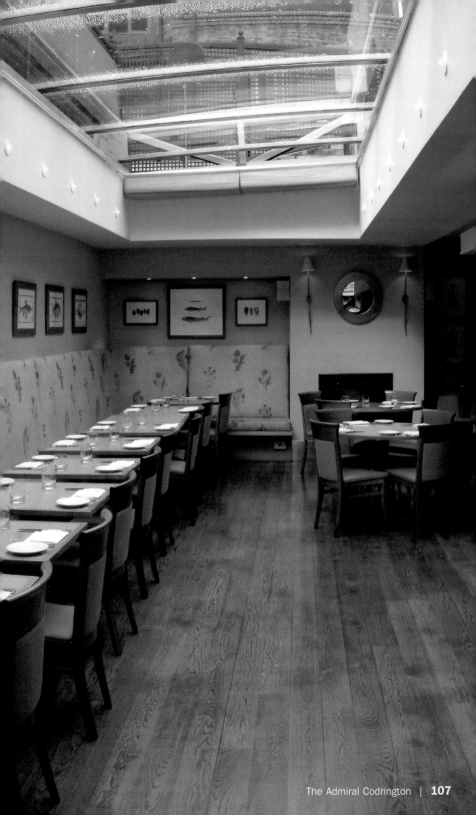

Admirals Cod

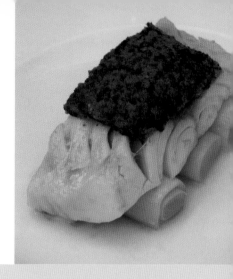

Admirals Kabeljau

Cabillaud de l'amiral

Bacalao Admiral

Merluzzo dell'ammiraglio

4 cod fillets, 6 oz each
5 oz soft butter
5 oz Gruyère-cheese, grated
3 oz Cheddar, grated
13 oz breadcrumbs
2 tbsp parsley, chopped
2 tbsp tarragon, chopped
2 tbsp chervil, chopped
Salt, pepper

Mix butter and cheese to a soft paste. Fold under the breadcrumbs and the herbs and season with salt and pepper. Shape into a roll and place in the refrigerator for 20 minutes.

4 oz button mushrooms
1 small onion, diced
2 tbsp olive oil
1 twig thyme
4 oz Crème double

Sauté mushrooms and diced onions in olive oil, add thyme and fill up with Crème double. Let simmer for 10 Minutes, chill, remove thyme and purée to a fine paste in the food processor. Put 1 tbsp of the mushroom mixture on each fillet and bake the in a 340 °F oven for 8–10 minutes. Remove, top with a slice of herb butter and brown for another minute in the oven. Serve on steamed leek.

4 Kabeljaufilets à 180 g
150 g weiche Butter
150 g Gruyère-Käse, gerieben
80 g Cheddar-Käse, gerieben
375 g Semmelbrösel
2 EL gehackte Petersilie
2 EL gehackter Estragon
2 EL gehackter Kerbel
Salz, Pfeffer

Die Butter und den Käse zu einer weichen Paste vermischen. Die Semmelbrösel und die Kräuter unterheben und mit Salz und Pfeffer würzen. Zu einer Rolle formen und für 20 Minuten in den Kühlschrank legen.

100 g Champignons, geviertelt
1 kleine Zwiebel, gewürfelt
2 EL Olivenöl
1 Zweig Thymian
120 ml Crème double

Champignons und Zwiebelwürfel in Olivenöl anschwitzen, Thymian zugeben und mit der Crème double aufgießen. 10 Minuten köcheln lassen, abkühlen, den Thymian entfernen und in einem Mixer zu einer feinen Paste verarbeiten. Auf jedes Filet einen EL der Pilzmasse geben und die Filets bei 170 °C 8–10 Minuten im Ofen garen. Herausnehmen, mit einer Scheibe der Kräuterbutter belegen und eine weitere Minute im Ofen überbräunen. Auf gedämpftem Lauch servieren.

4 filets de cabillaud de 180 g chacun
150 g de beurre ramolli
150 g de gruyère râpé
80 g de cheddar râpé
375 g de chapelure
2 c. à soupe de persil haché
2 c. à soupe d'estragon haché
2 c. à soupe de cerfeuil haché
Sel, poivre

Mélanger le beurre et le fromage en une pâte souple. Y ajouter la chapelure et les herbes. Assaisonner de sel et de poivre. Former un rouleau et le déposer 20 minutes au réfrigérateur.

100 g de champignons en quartiers
1 petit oignon en dés
2 c. à soupe d'huile d'olive
1 branche de thym
120 ml de crème double

Faire revenir dans l'huile d'olive les champignons et l'oignon, ajouter le thym et verser la crème double. Laisser frémir 10 minutes, laisser refroidir, enlever le thym et travailler au mixer pour obtenir une pâte fine. Etaler une c. à soupe de pâte de champignons sur chaque filet et les faire cuire au four à 170 °C de 8 à 10 minutes. Les sortir du four, déposer une rondelle de beurre aux herbes et faire gratiner encore une minute au four. Servir sur un poireau vapeur.

4 filetes de bacalao de 180 g cada uno
150 g de mantequilla blanda
150 g de queso Gruyère, rallado
80 g de queso Cheddar, rallado
375 g de migas de pan
2 cucharadas de perejil picado
2 cucharadas de estragón picado
2 cucharadas de perifollo picado
Sal, pimienta

Mezcle la mantequilla y el queso hasta conseguir una masa blanda. Añada las migas de pan y las hierbas, remueva y salpimiente. Forme un rollo y déjelo reposar en el frigorífico durante 20 minutos.

100 g de champiñones, en cuartos
1 cebolla pequeña, en dados
2 cucharadas de aceite de oliva
1 rama de tomillo
120 ml de nata espesa

Rehogue los champiñones y la cebolla en el aceite de oliva, incorpore el tomillo y vierta dentro la nata espesa. Hierva los ingredientes durante 10 minutos, déjelos enfriar, retire el tomillo y páselos por la batidora hasta conseguir una pasta fina. Unte cada filete con una cucharada de la pasta de champiñones y áselos después en el horno a 170 °C durante 8–10 minutos. Saque los filetes del horno, ponga encima una rodaja de la mantequilla de hierbas e introdúzcalos en el horno durante 1 minuto más. Sirva sobre puerro cocido al vapor.

4 filetti di merluzzo da 180 g l'uno
150 g di burro ammorbidito
150 g di gruviera grattugiato
80 g di formaggio Cheddar grattugiato
375 g di pangrattato
2 cucchiai di prezzemolo tritato
2 cucchiai di dragoncello tritato
2 cucchiai di cerfoglio tritato
Sale, pepe

Mescolate il burro e il formaggio fino ad ottenere una pasta morbida. Incorporatevi il pangrattato e le erbe aromatiche, salate e pepate. Formate un rotolo e mettetelo in frigorifero per 20 minuti.

100 g di champignon tagliati in quattro
1 cipolla piccola tagliata a dadini
2 cucchiai di olio d'oliva
1 rametto di timo
120 ml di doppia panna

Fate dorare gli champignon e i dadini di cipolla nell'olio d'oliva, aggiungete il timo e versatevi sopra la doppia panna. Lasciate crogiolare per 10 minuti, fate raffreddare, togliete il timo e passate in un frullatore fino ad ottenere una pasta fine. Mettete su ogni filetto un cucchiaio dell'impasto di funghi e fate cuocere i filetti in forno caldo a 170 °C per 8–10 minuti. Toglieteli dal forno, ricopriteli con una fetta di burro alle erbe aromatiche e passate di nuovo in forno per un altro minuto per farne dorare la superficie. Servite su porro cotto a vapore.

The Glasshouse

Design: Nelson Design | Head Chef: Anthony Boyd
Owner: Nigel Platts-Martin and Bruce Poole

14 Station Parade | Richmond, Surrey TW9 3PZ | Kew
Phone: +44 20 8940 6777
www.glasshouserestaurant.co.uk
Tube: Kew Gardens
Opening hours: Lunch Mon–Sat noon to 2:30 pm, Sun 12:30 pm to 3 pm, dinner
Mon–Thu 7 pm to 10:30 pm, Fri–Sat 6:30 pm to 10:30 pm, Sun 7 pm to 10 pm
Menu price: £35
Cuisine: Modern European

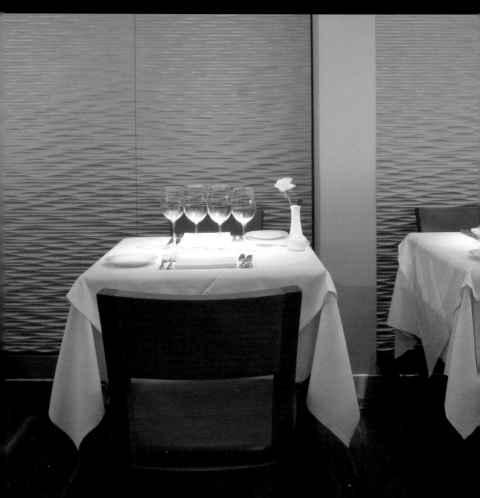

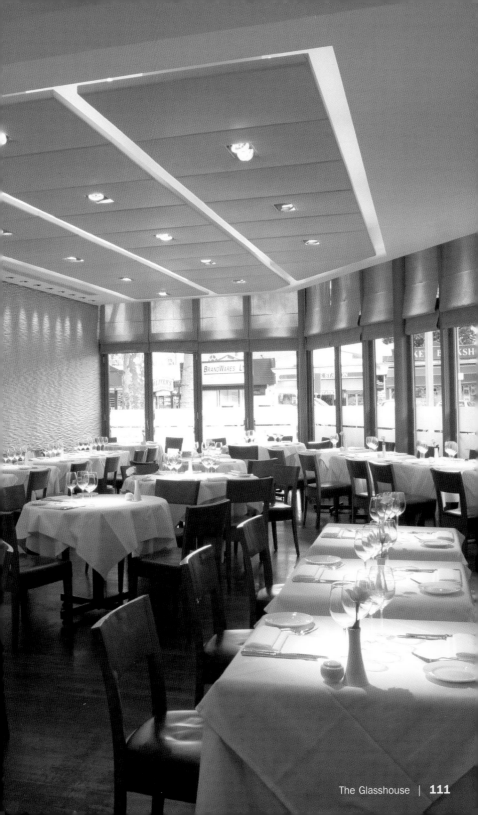

The River Café

Design: Richard Rogers | Chefs & Owners: Rose Gray, Ruth Rogers

Thames Wharf, Rainville Road | London, W6 9HA | Hammersmith
Phone: +44 20 7386 4200
www.rivercafe.co.uk | info@rivercafe.co.uk
Tube: Hammersmith
Opening hours: Lunch Mon–Fri 12:30 pm to 2:15 pm, Sat 12:30 pm to 2:30, Sun
noon to 3 pm, dinner Mon–Thurs 7 pm to 11 pm, Fri–Sat 7 pm to 11:20 pm
Average price: £28
Cuisine: Italian
Special features: Outside seating area, herb and vegetable garden, beside the Thames

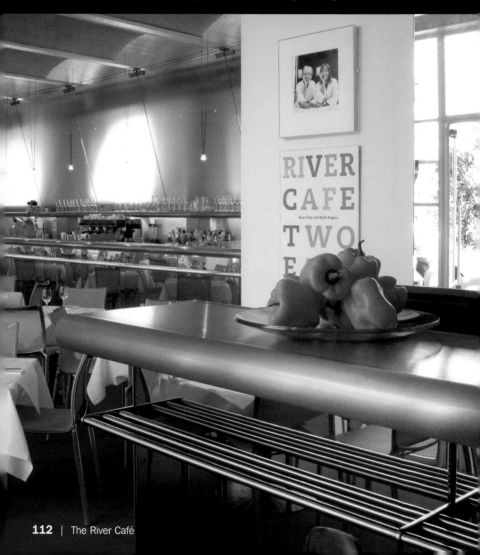

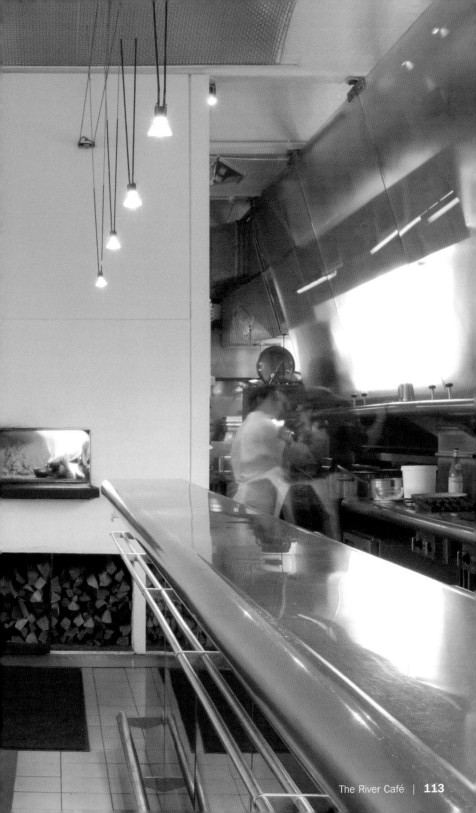

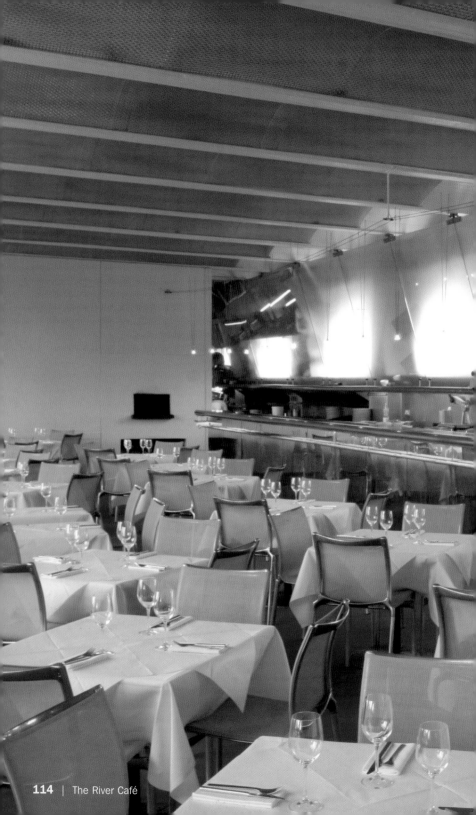

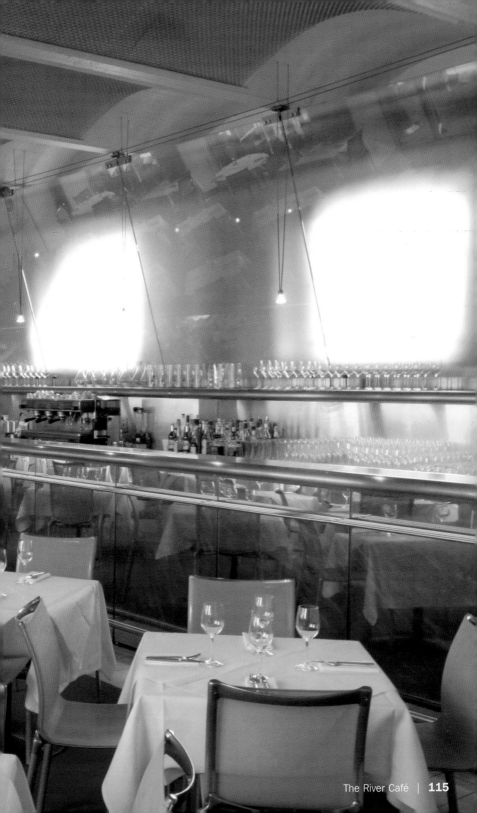

Red Mullet Spaghetti

Meerbarben-Spaghetti

Spaghettis au rouget

Espaguetis con salmonete

Spaghetti alle triglie

14 oz spaghetti
8 red mullet fillets
4 tbsp olive oil
1 tsp thyme, chopped
2 dried chilis, ground
14 oz cherry tomatoes, halved
4 tbsp black olives, stoned
Salt, pepper

Cook the spaghetti in a lot of salted water al dente. Place the red mullet fillets on a baking sheet, season with salt and pepper, sprinkle with 2 tbsp olive oil, thyme and chili and bake in a 390 °F oven for approx. 5 minutes. Fry the tomatoes in the leftover oil, fold under the olives and season for taste. Carefully mix spaghetti, tomatoes, olives and red mullet fillets and serve immediately.

400 g Spaghetti
8 Meerbarbenfilets
4 EL Olivenöl
1 TL Thymian, gehackt
2 getrocknete Chilis, gemahlen
400 g Kirschtomaten, halbiert
4 EL schwarze Oliven, entsteint
Salz, Pfeffer

Die Spaghetti in viel kochendem Salzwasser al dente garen. Meerbarbenfilets auf ein Backblech geben, mit Salz und Pfeffer würzen, mit 2 EL Olivenöl, Thymian und Chili bestreuen und bei 200 °C ca. 5 Minuten im Ofen garen. Die Tomaten in dem restlichen Öl anbraten, die Oliven unterheben und abschmecken. Spaghetti, Tomaten, Oliven und Meerbarbenfilets vorsichtig mischen und sofort servieren.

400 g de spaghettis
8 filets de rouget
4 c. à soupe d'huile d'olive
1 c. à café de thym haché
2 piments rouges séchés moulus
400 g de tomates cocktail coupées en deux
4 c. à soupe d'olives noires dénoyautées
Sel, poivre

Faire cuire les spaghettis al dente dans beaucoup d'eau. Placer les filets de rouget sur une tôle à pâtisserie, saler, poivrer, badigeonner de 2 c. à soupe d'huile d'olive, de thym et de piment et cuire 5 minutes au four à 200 °C. Faire revenir les tomates dans le reste de l'huile, ajouter les olives et assaisonner. Mélanger avec précaution les spaghettis, les tomates, les olives et les filets de rouget et servir sans attendre.

400 g de espaguetis
8 filetes de salmonete
4 cucharadas de aceite de oliva
1 cucharadita de tomillo, picado
2 guindillas secas, molidas
400 g de tomates cereza, en mitades
4 cucharadas de aceitunas negras, deshuesadas
Sal, pimienta

Cueza los espaguetis en agua hirviendo con sal hasta que estén al dente. Disponga los filetes de salmonete en una bandeja de horno, salpiméntelos, vierta por encima 2 cucharadas de aceite de oliva, esparza el tomillo y la guindilla y hornee durante aprox. 5 minutos a 200 °C. Sofría los tomates en el resto del aceite, añada las aceitunas, remueve y sazone. Mezcle cuidadosamente los espaguetis con las aceitunas y los filetes. Sirva inmediatamente.

400 g di spaghetti
8 filetti di triglie
4 cucchiai di olio d'oliva
1 cucchiaino di timo tritato
2 peperoncini essiccati e macinati
400 g di pomodorini ciliegia tagliati a metà
4 cucchiai di olive nere snocciolate
Sale, pepe

Cuocete gli spaghetti al dente in abbondante acqua salata. Disponete i filetti di triglia su una piastra da forno, salateli e pepateli, cospargeteli con 2 cucchiai di olio d'oliva, con timo e peperoncino e passateli in forno caldo a 200 °C per ca. 5 minuti. Fate rosolare i pomodori nell'olio restante, aggiungete le olive e correggete di sapore. Unite gli spaghetti e i filetti di triglia ai pomodori e alle olive e mescolate con cautela. Servite immediatamente.

The Zetter Restaurant

Design: Chetwood Associates, Precious McBane
Chef: Megan Jones | Owners: Michael Benyan, Mark Sainsbury

St John's Square, 86–88 Clerkenwell Road | London, EC1M 5RJ | Clerkenwell
Phone: +44 20 7324 4455
www.thezetter.com | info@thezetter.com
Tube: Farringdon
Opening hours: Breakfast Mon–Fri 7 am to 10:30 am, Sat–Sun 7:30 am to 11 am,
lunch Mon–Fri noon to 2:30 pm, dinner Mon–Sat 6 pm to 11 pm, Sun 6 pm to 10:30 pm
Average price: £30
Cuisine: Modern Italian

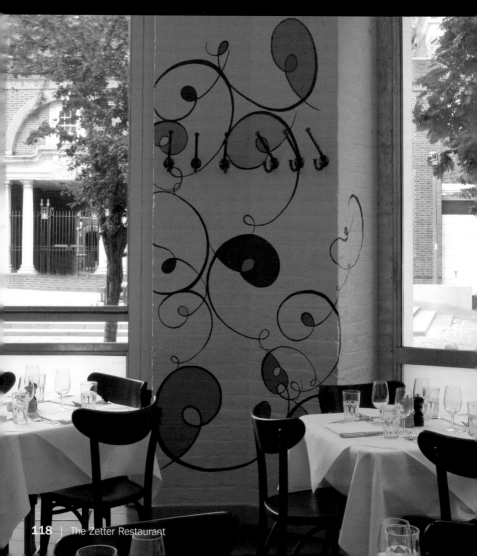

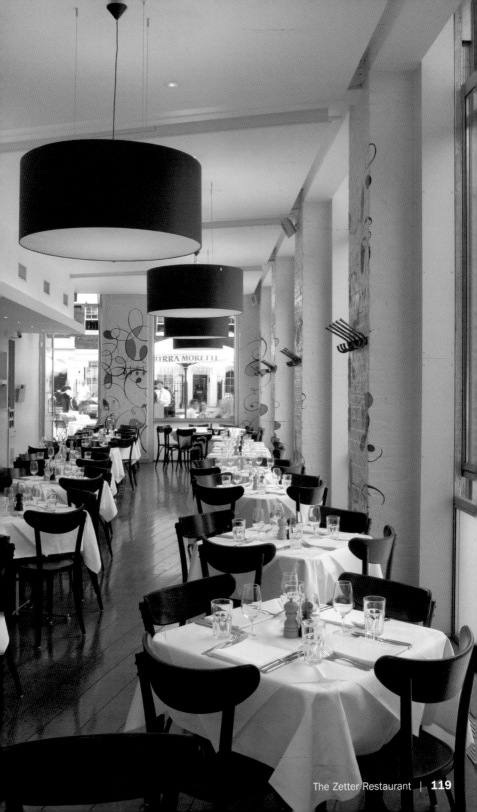

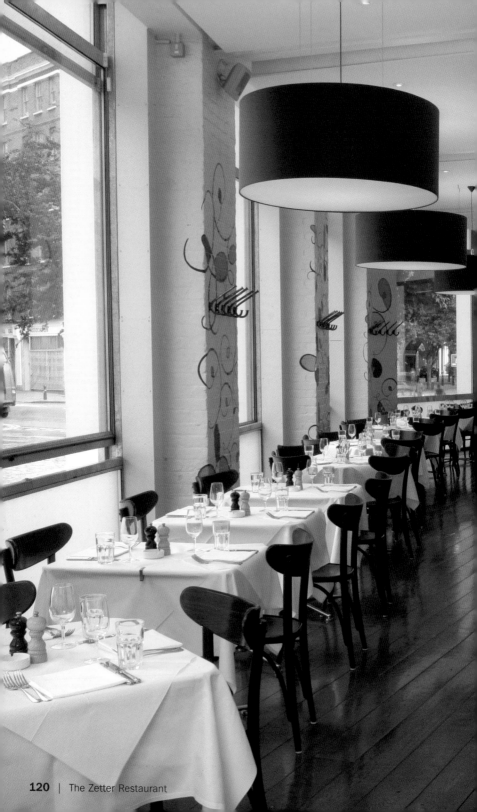

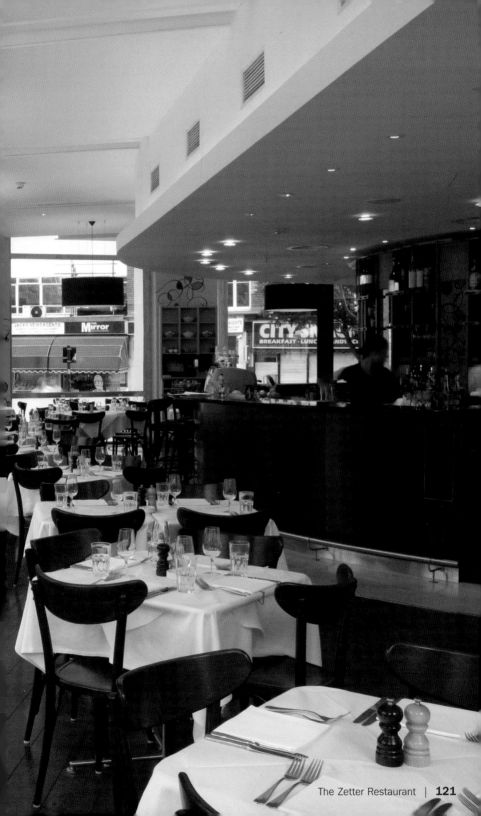

Tom's Delicatessen

Design: Michael Merhemitch | Chef: Stefano Tancredi
Owner: Tom Conran

226 Westbourne Grove | London, W11 2RH | Notting Hill
Phone: +44 20 7221 8818
Tube: Notting Hill Gate
Opening hours: Mon–Sat 8 am to 6 pm, Sun 9 am to 5 pm
Average price: £7
Cuisine: Delicatessen
Special features: Fresh British and artisanal produce

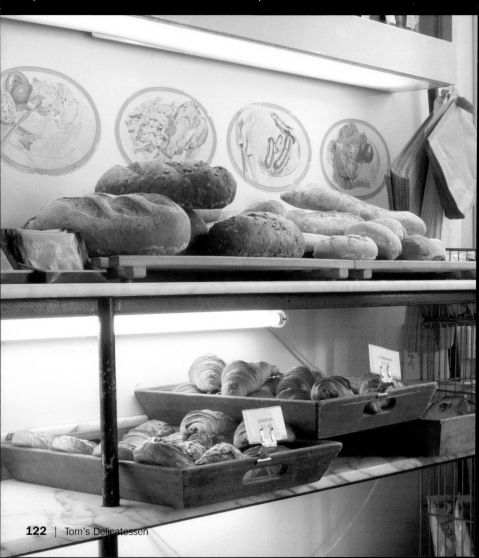

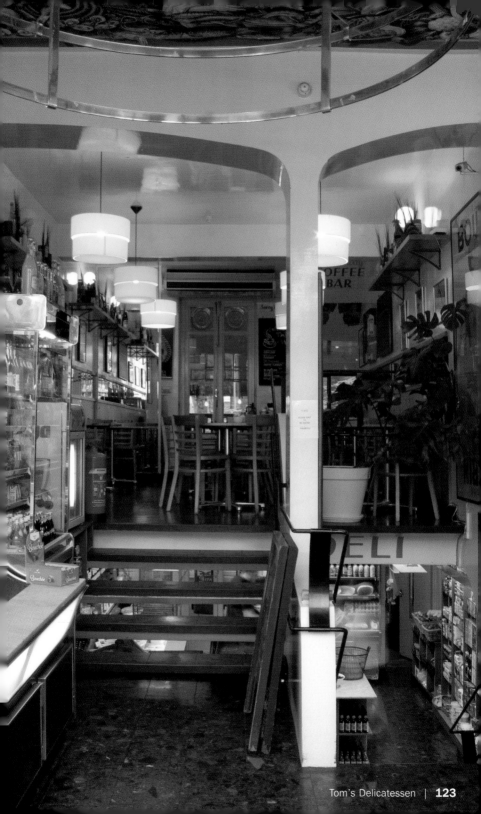

Umu

Design: Tony Chi | Chef: Ichiro Kubota | Owner: Marlon Abela

14–16 Bruton Place | London, W1J 6LX | Mayfair
Phone: +44 20 7499 8881
www.umurestaurant.com
Tube: Green Park, Bond Street
Opening hours: Mon–Sat lunch noon to 2:30 pm, dinner 6 pm to 11 pm
Average price: £17
Cuisine: Kyoto, Japanese
Special features: Michelin prized

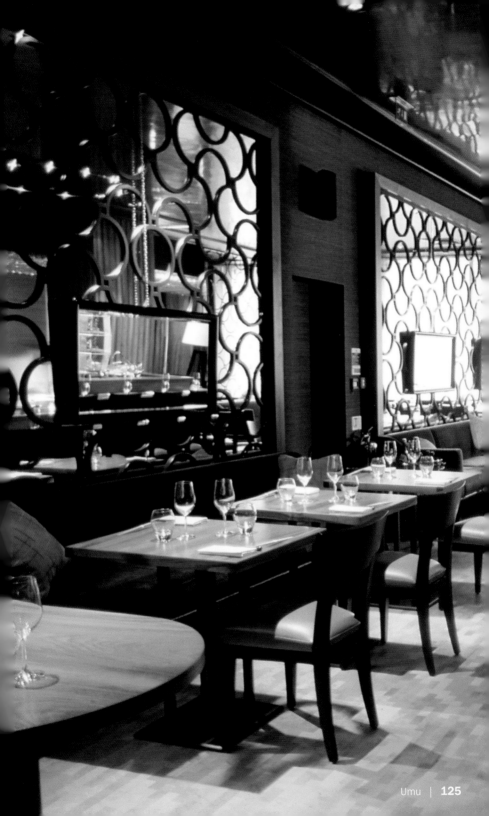

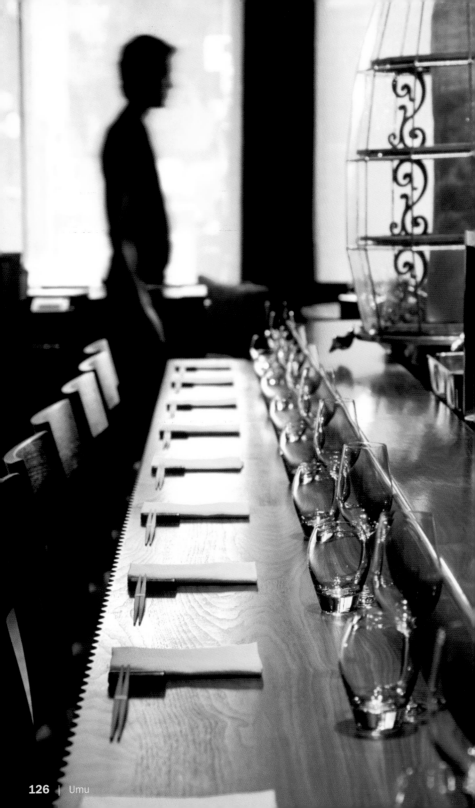

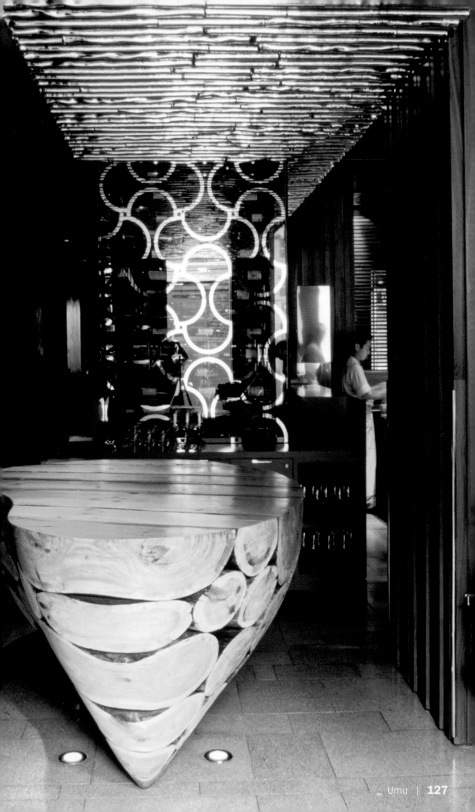

Sake Jelly
with Cherry Blossom Aroma

Sakegelee mit Kirschblütenaroma
Gelée de saké au parfum de fleur de cerisier
Jalea de sake con aroma de flor de cerezo
Gelatina di saké con aroma di fiori di ciliegio

500 ml sake
4 oz sugar
3 leaves gelatine
20 ml cherry blossom liqueur

7 oz guava purée
60 ml milk
15 ml Cointreau
2 tbsp sugar
Raspberries and mint leaves for decoration

Bring sake to a boil, dissolve sugar and take off stove. Soak gelatine in cold water, squeeze out and dissolve in the hot liquid. Chill, until sake begins to thicken, then stir in the cherry blossom liqueur and let set until firm. Mix the guava puree with the milk, Cointreau and sugar and chill. Spoon the sauce into a cocktail glass, place a cube of the jelly in it and decorate with raspberries and mint leaves.

500 ml Sake
120 g Zucker
3 Blatt Gelatine
20 ml Kirschblütenlikör

200 g Guavenpüree
60 ml Milch
15 ml Cointreau
2 EL Zucker
Himbeeren und Minzeblätter zur Dekoration

Sake aufkochen, den Zucker darin auflösen und vom Herd nehmen. Die Gelatine in kaltem Wasser einweichen, ausdrücken und in der heißen Flüssigkeit auflösen. Kaltstellen, bis die Sake einzudicken beginnt, dann den Kirschblütenlikör unterrühren und vollständig erstarren lassen. Das Guavenpüree mit der Milch, dem Cointreau und dem Zucker mischen und kaltstellen. Die Sauce in ein Cocktailglas geben, einen Würfel des Gelees darauf setzen und mit Himbeeren und Minzeblättern dekorieren.

500 ml de saké
120 g de sucre
3 feuilles de gélatine
20 ml de liqueur de fleur de cerisier

200 g de purée de goyave
60 ml de lait
15 ml de Cointreau
2 c. à soupe de sucre
Framboises et feuilles de menthe pour la décoration

Faire bouillir le saké, y diluer le sucre et retirer du feu. Faire tremper la gélatine dans de l'eau froide, l'essorer et l'ajouter au liquide bouillant. Mettre au frais jusqu'à ce que le saké commence à prendre, mélanger alors la liqueur de fleur de cerisier et laisser prendre complètement. Mélanger la purée de goyave avec le lait, le Cointreau et le sucre et mettre au frais. Verser la sauce dans un verre à cocktail, déposer un cube de gelée et décorer avec des framboises et des feuilles de menthe.

500 ml de sake
120 g de azúcar
3 láminas de gelatina
20 ml de licor de flores de cerezo

200 g de puré de guayaba
60 ml de leche
15 ml de Cointreau
2 cucharadas de azúcar
Frambuesas y hojas de menta para decorar

Lleve el sake a ebullición, disuelva dentro el azúcar y retire el cazo del fuego. Ponga la gelatina en agua para que se ablande, escurra después las láminas y derrítalas en el caldo caliente del sake. Introduzca la mezcla en el frigorífico hasta que el sake empiece a espesarse, añada después el licor de flores de cerezo, remueva y deje que se solidifique. Mezcle el puré de guayaba con la leche, el Cointreau y el azúcar y reserve en el frigorífico. Reparta la salsa en copas de cóctel, ponga dentro un cubito de la gelatina y decore con las frambuesas y las hojas de menta.

500 ml di saké
120 g di zucchero
3 fogli di gelatina
20 ml di liquore ai fiori di ciliegio

200 g di purea di guaiava
60 ml di latte
15 ml di Cointreau
2 cucchiai di zucchero
Lamponi e foglie di menta per decorare

Portate ad ebollizione il saké, fatevi sciogliere lo zucchero e toglietelo dal fuoco. Fate ammorbidire la gelatina in acqua fredda, strizzatela e scioglietela nel liquido bollente. Mettete a raffreddare finché il saké inizierà ad addensarsi, incorporate quindi il liquore ai fiori di ciliegio e lasciate rapprendere completamente. Mescolate la purea di guaiava al latte, al Cointreau e allo zucchero e mettete a raffreddare. Versate la salsa in un bicchiere da cocktail, mettetevi sopra un cubetto di gelatina e decorate con lamponi e foglie di menta.

Yauatcha

Design: Christian Liaigre | Chef: Wong Chiu Chun
Owner: Alan Yau

15–17 Broadwick Street | London, W1F 0DL | Soho
Phone: +44 20 7494 8888
Tube: Oxford Circus
Opening hours: Lunch Mon–Fri noon to 2:30 pm, Sat–Sun noon to 6 pm,
dinner Mon–Sat 6 pm to 11:30 pm, Sun 6 pm to 10:30 pm
Average price: £20
Cuisine: Chinese
Special features: Boutique tea house with an exquisite range of contemporary accessories

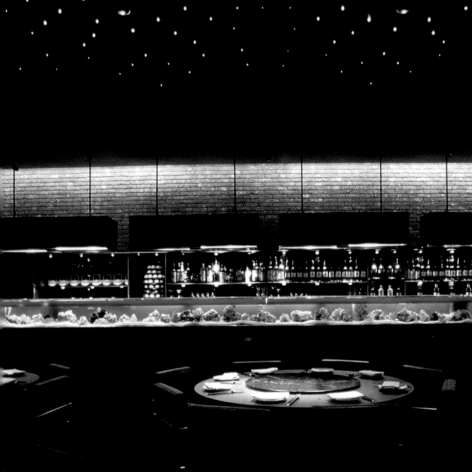

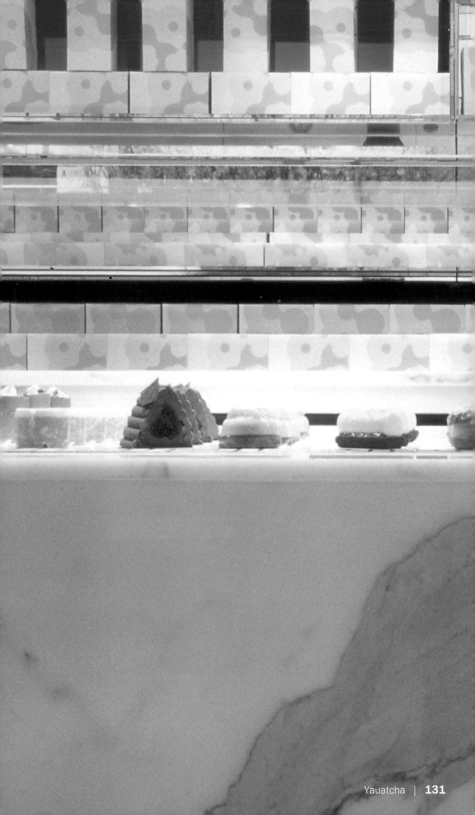

Chilean Sea bass Mooli Roll

Chilenische Wolfsbarsch Mooli Rolle

Rouleau de mooli au loup de mer du Chili

Rollitos de lubina chilena con mooli

Rotolo cinese di mooli con branzino

12 pieces sea bass, 1 ½ oz each
1 mooli (Asian radish), in 2 x 4 inch stripes
12 blades of Chinese chives with blossom
12 thin slices ginger
12 thin slices Thai onions

Blanch 12 even slices of mooli and chill. Place each fish on one piece of mooli, cover with a piece of ginger and Thai onion and shape into a roll. Tie with a blade of chives and steam for approx. 5 minutes until the fish is done. Serve with some of the steaming liquid.

12 Stück Wolfsbarsch, á 40 g
1 Mooli (asiatischer Rettich), in 5 mal 10 cm breiten Streifen
12 Halme chinesischer Schnittlauch mit Blüten
12 dünne Scheiben Ingwer
12 dünne Scheiben Thai–Zwiebel

12 gleichmäßige Streifen Mooli blanchieren und abkühlen lassen. Den Fisch auf jeweils einer Streifen Mooli legen, ein Stück Ingwer und Thai-Zwiebel darauf legen und einwickeln. Mit einem Schnittlauchhalm zubinden und für ca. 5 Minuten dämpfen, bis der Fisch gar ist. In etwas Brühe servieren.

12 morceaux de loup de mer de 40 g chacun
1 mooli (radis asiatique) en tranches de 5 cm sur 10
12 brins de ciboule chinoise avec les fleurs
12 fines tranches de gingembre
12 fines tranches d'oignon thaï

Faire blanchir 12 tranches régulières de mooli et laisser refroidir. Coucher le poisson sur une tranche de mooli avec un morceau de gingembre et une tranche d'oignon thaï et envelopper. Nouer avec un brin de ciboule et faire cuire à la vapeur env. 5 minutes jusqu'à ce que le poisson soit cuit. Servir dans un peu de bouillon.

12 lubinas de 40 g cada una
1 mooli (rábano asiático), in 5 tiras de 10 cm de ancho
12 halmes, cebollino chino con flores
12 tiras finas de jengibre
12 tiras finas de cebolla thai

Escalde 12 tiras iguales de mooli y déjelas enfriar. Ponga una lubina sobre cada tira, un trozo de jengibre y de cebolla thai y haga rollitos. Ciérrelos atando a su alrededor un cebollino y cocínelos al vapor durante aprox. 5 minutos hasta que el pescado esté hecho. Sírvalos con un poco de caldo.

12 pezzi di branzino da 40 g l'uno
1 mooli (ravanellone asiatico) tagliato a strisce di 5 x 10 cm
12 steli di erba cipollina cinese con fiori
12 fette sottili di zenzero
12 fette sottili di cipolla tailandese

Sbollentate 12 strisce uguali di mooli e lasciatele raffreddare. Sistemate un pezzo di pesce su ciascuna striscia di mooli, mettetevi sopra un pezzo di zenzero e di cipolla tailandese e avvolgete. Legate con uno stelo di erba cipollina e fate cuocere a vapore per ca. 5 minuti finché il pesce sarà cotto. Servite in un po' di brodo.

Regent's Park

⟵ 12

⟵ 26

Paddington Station

Oxford Street 1

2

17

Hyde Park

Hyde Park Corner

10 5 18

Sloane Street

22

Victoria Station

24

23

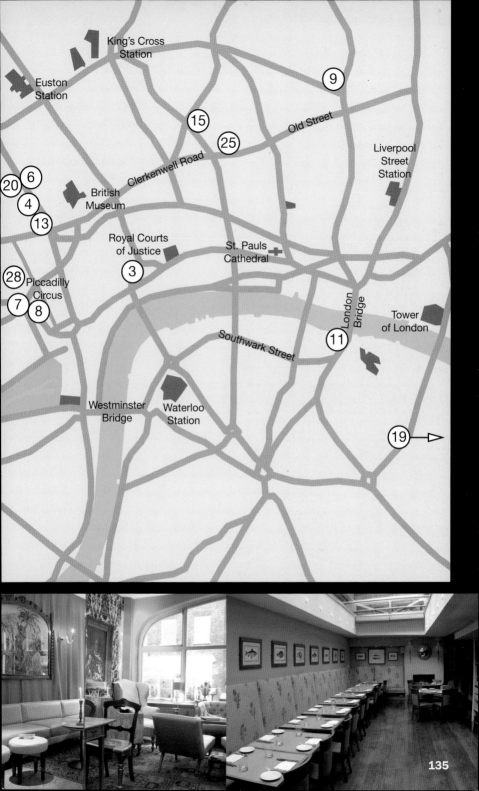

Cool Restaurants

Amsterdam
ISBN 978-3-8238-4588-1

Barcelona
ISBN 978-3-8238-4586-7

Berlin
ISBN 978-3-8238-4585-0

Brussels (*)
ISBN 978-3-8327-9065-3

Cape Town
ISBN 978-3-8327-9103-2

Chicago
ISBN 978-3-8327-9018-9

Cologne
ISBN 978-3-8327-9117-9

Copenhagen
ISBN 978-3-8327-9146-9

Côte d'Azur
ISBN 978-3-8327-9040-0

Dubai
ISBN 978-3-8327-9149-0

Frankfurt
ISBN 978-3-8327-9118-6

Hamburg
ISBN 978-3-8238-4599-7

Hong Kong
ISBN 978-3-8327-9111-7

Istanbul
ISBN 978-3-8327-9115-5

Las Vegas
ISBN 978-3-8327-9116-2

London 2nd edition
ISBN 978-3-8327-9131-5

Los Angeles
ISBN 978-3-8238-4589-8

Madrid
ISBN 978-3-8327-9029-5

Mallorca/Ibiza
ISBN 978-3-8327-9113-1

Miami
ISBN 978-3-8327-9066-0

Milan
ISBN 978-3-8238-4587-4

Moscow
ISBN 978-3-8327-9147-6

Munich
ISBN 978-3-8327-9019-6

New York 2nd edition
ISBN 978-3-8327-9130-8

Paris 2nd edition
ISBN 978-3-8327-9129-2

Prague
ISBN 978-3-8327-9068-4

Rome
ISBN 978-3-8327-9028-8

San Francisco
ISBN 978-3-8327-9067-7

Shanghai
ISBN 978-3-8327-9050-9

Stockholm
ISBN 978-3-8327-9176-6

Sydney
ISBN 978-3-8327-9027-1

Tokyo
ISBN 978-3-8238-4590-4

Toscana
ISBN 978-3-8327-9102-5

Vienna
ISBN 978-3-8327-9020-2

Zurich
ISBN 978-3-8327-9069-1

COOL SHOPS

BARCELONA
ISBN 978-3-8327-9073-8

BERLIN
ISBN 978-3-8327-9070-7

HAMBURG
ISBN 978-3-8327-9120-9

HONG KONG
ISBN 978-3-8327-9121-6

LONDON
ISBN 978-3-8327-9038-7

LOS ANGELES
ISBN 978-3-8327-9071-4

MILAN
ISBN 978-3-8327-9022-6

MUNICH
ISBN 978-3-8327-9072-1

NEW YORK
ISBN 978-3-8327-9021-9

PARIS
ISBN 978-3-8327-9037-0

TOKYO
ISBN 978-3-8238-9122-3

COOL SPOTS

COTE D'AZUR
ISBN 978-3-8327-9154-4

LAS VEGAS
ISBN 978-3-8327-9152-0

MALLORCA/IBIZA
ISBN 978-3-8327-9123-0

MIAMI/SOUTH BEACH
ISBN 978-3-8327-9153-7

SALZBURG/KITZBÜHL
ISBN 978-3-8327-9177-3

Size: 14.6 x 22.5 cm
5¾ x 8¾ in.
136 pp, Flexicover
c. 130 color photographs
Text in English, German, French
Spanish, Italian or (*) Dutch

teNeues